GRAPHIC DESIGN
Vision, Process, Product

Louis D. Ocepek

Professor Emeritus of Art
New Mexico State University

Upper Saddle River, New Jersey 07458

Library of Congress Cataloging-in-Publication Data
Ocepek, Louis.
 Graphic design : vision, process, product / Louis Ocepek.
 p. cm.
 Includes index.
 ISBN 0-13-041883-8
 1. Graphic arts—Technique. I. Title.

NC1000 .O34 2003
741.6—dc21 2002029275

VP/Editorial Director: Charlyce Jones-Owen
Publisher: Bud Therien
Editorial Assistant: Sasha Anderson
Managing Editor: Jan Stephan
Production Liaison: Joanne Hakim
Project Manager: Emily Autumn, Clarinda Publication Services
Prepress and Manufacturing Buyer: Sherry Lewis
Art Director: Jayne Conte
Cover Art: Louis D. Ocepek
Director, Image Resource Center: Melinda Reo
Manager, Rights and Permissions: Zina Arabia
Interior Image Specialist: Beth Boyd-Brenzel
Image Permission Coordinator: Debbie Latronica
Marketing Manager: Chris Ruel

This book was set in 10/13 New Aster by The Clarinda Company and was printed and bound by R. R. Donnelley. The cover was printed by Phoenix Color Corp.

© 2003 by Pearson Education, Inc.
Upper Saddle River, New Jersey 07458

Printed in the United States of America

10 9 8 7 6 5 4 3 2 1

ISBN 0-13-041883-8

Pearson Education Ltd., London
Pearson Education Australia, PTY. Limited, Sydney
Pearson Education Singapore, Pte. Ltd
Pearson Education North Asia Ltd, Hong Kong
Pearson Education Canada, Ltd., Toronto
Pearson Educación de Mexico, S.A. de C.V.
Pearson Education—Japan, Tokyo
Pearson Education Malaysia, Pte. Ltd
Pearson Education, Upper Saddle River, New Jersey

Contents

Introduction

The principles of graphic design are universal, transcending period and style, providing creative sustenance to generations of designers. Rarely, if ever, do designers employ the principles of graphic design singly, or even in pairs. Instead, visual communication consists of an intricate interplay of elements, the integrated effect of the whole transcending its parts. Although the design process itself often progresses in a logical manner, it remains inherently dynamic, allowing for spontaneity, intuition, and change.

To establish an understanding of design essentials, the chapters of this book are arranged progressively. The early chapters introduce the foundations of design: content, parameters and problem solving, the design process, and attitude and point of view. The middle section emphasizes words, images, and organization, while later chapters explore the formal elements of design such as line, shape, and color. The final chapter is a study of graphic production, which examines relationships between design concept, fabrication, and the assorted media of graphic design.

The object of this book is to view graphic design in the context of daily life. This approach is meant to demonstrate the importance of graphic design as an integral service to all aspects of society. The design examples used throughout the book were chosen for their intelligence, ingenuity, and superior production values, as well as their demonstrated application of particular design principles. In the case of classic and modernist work, I emphasize their historical significance and continuing relevance.

The principles can be studied in order, or in various combinations, such as letters and words with color, or design process with content. At the end of each chapter I provide a list of key words, which not only establishes the specialized vocabulary used in the profession, but also provides a framework for discussion and critique.

My goal is not to direct the designer toward one particular esthetic, but rather to demonstrate how a thorough understanding of the principles of graphic design enhances discovery, diversity, and individual creativity.

Acknowledgments

I wish to thank Mary Wolf for her belief in this project and her expert editorial assistance; Joshua Rose and New Mexico State University for granting me time to write; Peter Gilleran for opening my eyes to the art of design; and Bill Green for his enthusiasm and good will. I would also like to thank reviewers Julie G. Mitchell, University of Cincinnati—Raymond Walters College and Andrew Bayroff, The Art Institute of Los Angeles. They offered valuable comments and insight. I also wish to acknowledge Gerald Moore for providing excellent photography, and the generosity of the designers, museums, galleries, and corporations whose work appears in this book.

LOUIS D. OCEPEK
PROFESSOR EMERITUS OF ART
NEW MEXICO STATE UNIVERSITY

1 Content

Graphic design is created in response to the visual *communication* needs of a client, who has a specific message to convey to an audience. Clients with graphic communication needs come from every aspect of society, from cultural to commercial; consequently, graphic design content is exceptionally inclusive. Graphic designers can typically expect to produce work in the following areas of communication:

Advertising design
Architectural signage and environmental design
Book and publication design
Business communications
Electronic communications
Film, video, and computer graphics
Identity systems
Information and exhibition design
Packaging and point-of-purchase design
Social, cultural, and political communications

Each of the areas listed above is a specialized class of communication design, with a unique visual/verbal content usually defined by the client. Through discussion and analysis, designers work in partnership with the client to first establish a communications strategy, and then use words and images to fulfill the agreed-upon objectives. Projects are created using the tools, techniques, and styles that will most effectively express the individualized nature of each assignment. (See **fig. 1-1**).

For example, in *information design,* the communication of specific scientific or statistical content is the primary objective. This kind of content can be bland and uninteresting when presented without attention to esthetic quality. Presenting information with artistic distinction is not only more likely to engage the reader, but the results are more satisfying to the designer

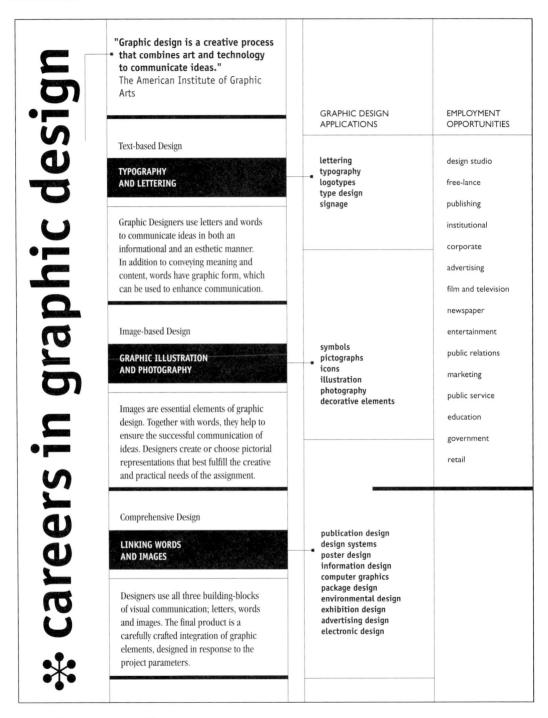

careers in graphic design

"Graphic design is a creative process that combines art and technology to communicate ideas."
The American Institute of Graphic Arts

	GRAPHIC DESIGN APPLICATIONS	EMPLOYMENT OPPORTUNITIES

Text-based Design

TYPOGRAPHY AND LETTERING

lettering
typography
logotypes
type design
signage

design studio

free-lance

publishing

institutional

corporate

Graphic Designers use letters and words to communicate ideas in both an informational and an esthetic manner. In addition to conveying meaning and content, words have graphic form, which can be used to enhance communication.

advertising

film and television

newspaper

entertainment

Image-based Design

GRAPHIC ILLUSTRATION AND PHOTOGRAPHY

symbols
pictographs
icons
illustration
photography
decorative elements

public relations

marketing

public service

Images are essential elements of graphic design. Together with words, they help to ensure the successful communication of ideas. Designers create or choose pictorial representations that best fulfill the creative and practical needs of the assignment.

education

government

retail

Comprehensive Design

LINKING WORDS AND IMAGES

publication design
design systems
poster design
information design
computer graphics
package design
environmental design
exhibition design
advertising design
electronic design

Designers use all three building-blocks of visual communication; letters, words and images. The final product is a carefully crafted integration of graphic elements, designed in response to the project parameters.

Fig. 1-1. Careers in graphic design.

and client. Andrea Cellarius's 1661 celestial chart of the northern constellations demonstrates how scientific information of the time could be presented accurately but with imagination **(fig. 1-2)**. The large copperplate engraving, from the *Harmonia Macrocosmica*, an atlas of astronomical diagrams, is a planispheric (planar) representation of a section of the cosmos, showing the positions of the stars that make up the constellations.

To early astronomers, the contours of these constellations resembled those of animals and mythological figures, a feature that made it easier for observers to locate and remember them. In the seventeenth century, the positions of the stars were an important feature of everyday life, used to not only forecast the future and influence important decisions, but also to serve as a navigational guide. Not surprisingly, a market arose for graphic representations of these astronomical charts. Cellarius's engraving strikes a delicate balance between artistic expression and astronomical fact, picturing the fantastically complex and interactive figures of the constellations without obscuring the all-important locations of individual stars. As with contemporary graphic design, the production of such a magnificent work required the cooperation of a company

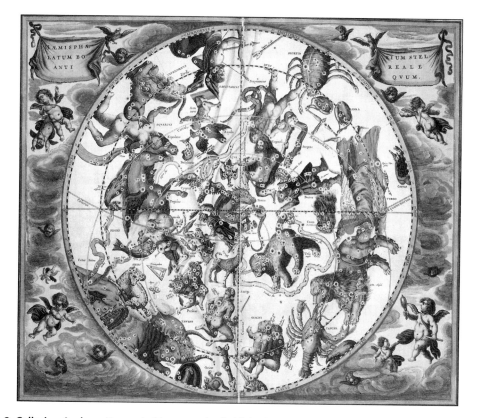

Fig. 1-2. Cellarius, Andrea, *Harmonia Macrocosmica,* Published in 1661, Amsterdam. Page 186.2 Victoria & Albert Museum, London / Art Resource, NY.

of specialists—in this case an astronomer, a cartographer (mapmaker), an artist/engraver, and a publisher.

There are times when catastrophic events require national and international mobilization. Graphic designers can contribute to such an effort by using their communication skills to move people to action. Following its entry into World War II in 1941, the United States embarked on a massive increase in military and industrial production. Graphic *propaganda* was needed to generate support and enthusiasm for the effort, and some of the finest designers in the world rallied to the cause. French designer and illustrator Jean Carlu, living in the United States at the time the Germans invaded Paris, captured the heroic spirit of the time in his award-winning wartime poster *America's Answer! Production* **(fig. 1-3)**. Carlu's inspired design, with its dynamically canted layout and powerful linking of word and image, dramatizes the strength and significance of the American workforce, so vital to a successful war effort. The angled layout, the elemental imagery, the use of negative space, and the declarative headline are typical of European modernism, which had a transforming effect on American design.

Propaganda is used by groups on both sides of an issue, to disseminate their respective viewpoints. Seymour Chwast (together with Milton Glaser,

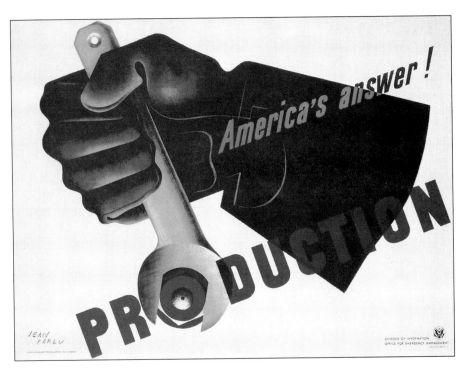

Fig. 1-3. Carlu, Jean. *America's Answer! Production,* 1942. Smithsonian American Art Museum, Washington, DC / Art Resource, NY.

his former partner in Pushpin Studios) is one of the most important and influential American designers of the twentieth century. Working brilliantly in a wide range of styles and mediums, Chwast is consistently intelligent and unpredictable, his work informed by his personal interest in the arts, politics, and world culture. His 1982 antinuke poster, *March for Peace and Justice*, is a witty visual icon symbolizing the strength of the Peace movement as achieved through the mobilization of ordinary people at the grass-roots level **(fig. 1-4)**. Chwast, in his book *The Left-Handed Designer*, says he was asked by the Peace March Committee to create a positive image of peace, rather than a negative one of war. Chwast's concisely drawn graphic illustration, with its light, almost cheery outlook, is an interesting contrast to the seriousness of the issue. Only the legs of the marchers are seen, each one representing a different walk of life, united under the overarching dove of peace. The word *March* is equally prominent, each of its five letters rendered in a different color. It literally marches across the top of the layout, mirrored by the assortment of legs below. The poster's message is cleverly communicated with boldness, imagination, and Chwast's signature sense of humor.

Although organizations dealing with social issues usually operate outside the world of commerce, they too include professional graphic design in their budget plans. The content of socially responsible graphic design raises

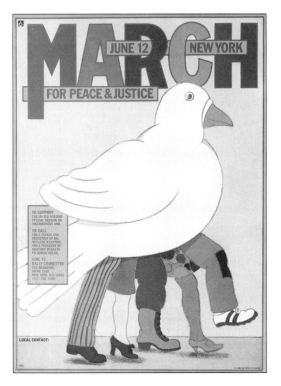

Fig. 1-4. Seymour Chwast, poster, *March for Peace and Justice.* Peace March Committee, 1982.

public awareness while moving individuals to some kind of personal action. The conference *Sepultadas en la Frontera (Burials on the Border)* brought scholars and professionals from both sides of the United States–Mexico border to the New Mexico State University campus to discuss the social, political, and law-enforcement issues surrounding the brutal murders of nearly 200 young women over a six-year period in Ciudad Juárez, Mexico.

The conference poster had to convey the life-and-death seriousness of the situation, involving issues of race, gender, and drugs, as well as socio-economic upheavals wrought by the explosive growth of the maquila (twin plant) industry. Even a quick glance at this poster communicates meaningful content **(fig. 1-5)**. The startling image of the young woman's face, cropped inside the contours of a rough cross, instantly engages the viewer's attention. Life and death are fused into one symbolic unit. The dramatically torn cross, punched out of a symbolically pink color field, emulates the improvised symbol used by activists on the streets of Juárez. The black and white photograph, with its exaggerated halftone dots, and the roughly distorted type, are reminiscent of street-level vernacular design (where much of the violence occurred). Chad Ballard's poster is an abrupt and disruptive symbol of the violence itself, raising public awareness of the hopelessness and fear experienced by women on both sides of the border.

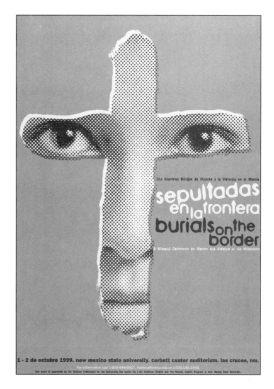

Fig. 1-5. Chad Ballard, poster, *Sepultadas en la Frontera (Burials on the Border).* Women's Studies Program, New Mexico State University, 1999.

Designing graphics for cultural events; such as exhibitions, concerts, and performances, is satisfying, but uniquely challenging as well. On the positive side, the audience is already culturally aware, committed to the enjoyment and support of art, music, and the finer things of life. The imagery for cultural events is therefore more likely to be artistic, with more latitude for experimentation. On the somewhat negative side, the designer often has to use prescribed imagery, such as a particular painting, or a performer's mug shot. There is typically an abundance of text (the performers, location, dates, hours, ticket prices, etc.) and, of course, there is the need to attract an audience. Rick Valicenti and Mark Rattin, of Thirst, commissioned by the Arts Club of Chicago to design a poster for the thirtieth anniversary of the neo-Dada group Fluxus, began their design process by immersing themselves in the group's creative mind-set.

Their stunning, large-scale poster is a tribute to the questioning, alternative nature of Fluxus, breathtaking in the expressiveness of its radical typography and its superb production values **(fig. 1-6)**. The flowing title-copy, *Fluxus Vivus,* a fractured montage of weirdly colored video images, is revolutionary in its esthetic "violations," challenging our conventional conceptions of "good design" and "legibility." Nothing is fixed; surfaces are unstable and threaten to splinter. Peripheral spaces are filled to the brim with densely packed layers of text, the reader forced to decode even such elemental material as dates, locations, and sponsors. The aggressively graphic poster invades the viewer's consciousness, provoking reaction. The designer's willingness to personally experience the theoretical principles of Fluxus lends esthetic muscle to their uncompromising design.

As mentioned, an invigorating aspect of graphic design is its diverse client base, since every client has a different need. One never knows what kind of interesting project the next phone call will bring. The British design group, Why Not Associates, collaborated with Gordon Young to create a public memorial to the immensely popular comedian Eric Morecambe, working with content on an environmental scale, using media not typically associated with graphic design **(fig. 1-7)**.

In contrast to the relatively short-lived, ephemeral nature of print projects, memorials are, of course, expected to last a long time. The dramatically lighted Morecambe Memorial features an animated statue of the comic at the center of its circular plaza, together with a winding typographic path, engraved with witticisms and lyrics of the Morecambe and Wise theme song, "Bring Me Sunshine." Thus, the *form* of the plaza is literally and figuratively integrated with the *content,* a living tribute to a favorite public figure. In contrast to the average memorial, where visitors look at the usual statue of a celebrated figure, centered in the middle of an open space, and leave, the design of the Morecambe Memorial encourages interaction. Led on by the graphic text at their feet, they recall wonderful moments from Morecambe's career. On the practical level, the success of a project of this scope is largely

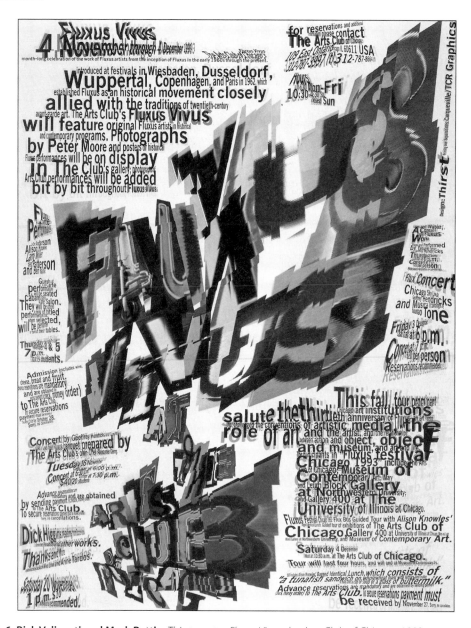

Fig. 1-6. Rick Valicenti and Mark Rattin, Thirst, poster, *Fluxus Vivus,* the Arts Club of Chicago, 1993.

dependent on the designer's ability and willingness to work with diverse professionals and subcontractors, on a large scale and with atypical, permanent materials. On the conceptual level, the respectful and affectionate memorial pays lively tribute to a man much loved by his public.

James A. Houff's promotional poster for the comprehensive design firm Peterhans, Rea and King (PRK) publicizes, in words and images, the

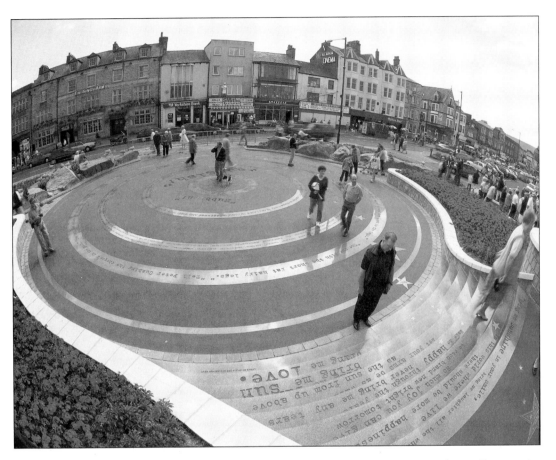

Fig. 1-7. Why Not Associates, Eric Morecambe Typographic Memorial. Lancaster City Council, 1999. Photography, Jerry Hardman-Jones.

company's design philosophy and the services it offers **(fig. 1-8)**. This kind of content is rather ordinary, and in the hands of a lesser designer, the project could be boringly predictable. Houff, however, transcends the routine nature of the assignment by creating an elaborately articulate, almost theatrical assemblage of information. The theme of the poster (STEP) is based on a quotation, featured in the upper left corner of the layout, by the German philosopher Goethe, which encourages boldness, commitment, and decisiveness. By associating PRK with Goethe, a level of dignity, initiative, and smartness is ascribed to the company. These attributes, which form the basis of PRK's own philosophy, are pictured in a variety of ways.

The word *STEP* is handsomely displayed in large sans serif caps, floating over an atmospheric montage of photographic images. In the poster's lower right corner is a neatly designed word/image tableau defining the various connotations of "step," each of which applies positively to the client's

Fig. 1-8. James A. Houff, poster, *STEP.*
Peterhans, Rea and King, 1991.

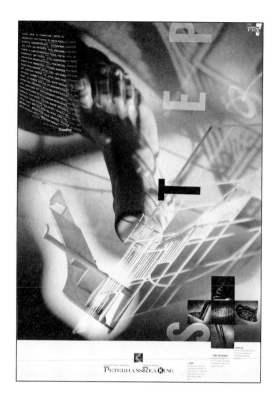

design practice (such as a series of actions, to assert, to advance, to establish presence). The montage of a finely crafted architectural model, a fragment of classical sculpture, and a dramatically placed architectural detail symbolizes quality, tradition, knowledge, and creativity. On the reverse side of the sheet, arranged in a simple grid layout, is a photographic catalog of PRK projects, bearing out their objective "to enhance, by design, the look, use, and effect of objects, places and experiences." Although the principal typeface used throughout the poster is Paul Renner's 1928 Futura (suggesting the firm's knowledge and appreciation of fine design from an earlier period), Houff's graphic sensibility is thoroughly avant-garde, rich with finely shaded symbolism and visual nuance.

An *identity mark,* such as a logotype (logo), lettermark, symbol, or pictograph, is used to publicly identify a business or organization. Although public identification is the principal function of a mark, it also carries symbolic and/or literal content. Even the most severely stylized symbol communicates information, attitude, and image. The typographic style of a logo, or the pictorial characteristics of a symbol or pictograph, is used to communicate something about the product or service offered by the organization. The consistent *application* of the mark signifies prosperity, organization, professionalism, and good management. An identity mark for a graphic design business is

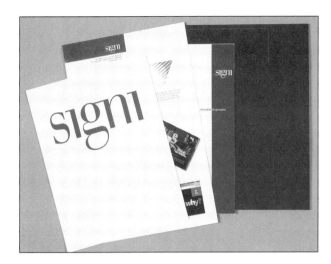

Fig. 1-9. René Galindo, Signi, corporate identity. Mexico City, Mexico, 1996.

particularly vital because it also serves as a sample of the company's work. The theme behind the mark designed by René Galindo for his own design business, Signi, starts with the name itself **(fig. 1-9)**. The word *Signi* is derived from words such as *sign, signify, signet,* and *signal,* all of which bear some relationship to the work of a design company. The tastefully modified typeface, restrained, elegant, and beautifully rendered, articulates the skill, preeminence, and professionalism of the Signi studio. The color red was chosen for its affirmative energy, symbolizing the life force and positive action. By building its identity from the ground up, and applying its design style consistently to each component of the company's promotional material, Signi successfully displays its design prowess while accentuating its business acumen.

Vaughn Wedeen Creative was called upon to design a very complicated graphic tool for U S West Communications (now Qwest Communications). The company, introducing its Leveraged Compensation Plan to employees, needed a calculator its employees could use to estimate their earnings potential under a new agreement **(fig. 1-10)**. The calculator, which consists of a slotted, cardstock sleeve with a sliding inner card, by necessity contains a profusion of text, requiring the use of very small type sizes in a very small layout space. The production standards for a project of this kind are very high; in order for the calculator to work properly, the figures on the inner card have to be perfectly aligned with the die-cut slots and text on the outer sleeve. Vaughn Wedeen used gridlike subdivisions, bold sans serif type, and color-coding to bring clarity and functionality to the complicated subject matter. As a result, the calculator is inviting and easy to use, while the rhythmic pattern of the typographic arrangement and the coordinated color palette are visually pleasing. The project demonstrates how a designer can bring coherence and esthetic quality to the most pedestrian assignment.

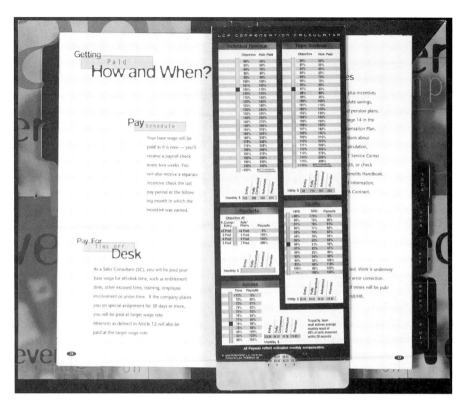

Fig. 1-10. Vaughn Wedeen Creative, *Compensation Calculator. Employee's Guidebook.* U S West Communications, 1995.

Three-dimensional *packaging* and *point-of-purchase displays* are specialized applications related to retail sales. Kilmer and Kilmer, Brand Consultants, were asked to create an in-store display for Hellowwear, a line of outdoor wear for young people **(fig. 1-11)**. Such a display has two functions: to attract the attention of shoppers, and to display the clothing line and provide organized storage space for inventory. To fulfill the first requirement, the Hellowwear display had to visually appeal to the hip style of the youthful target audience. To achieve this goal, Kilmer and Kilmer created a brash display unit that says, "Stop here." At the top of the sleek, angular exhibit is a bright red open hand, positioned on a scalelike sculptural device (perhaps a hip-o-meter?) featuring the brand name, Hellowwear, in bold, uppercase sans serif letters. The effect of the hand is like that of a traffic cop. The display also looks like a groovy bureau that a kid would like to have in his or her room, decorated with brightly colored graphics, with lots of storage space. The Hellowwear display successfully targets a very particular stylistic trend even as it conveys an image of quality and durability, proving that even a store display has content!

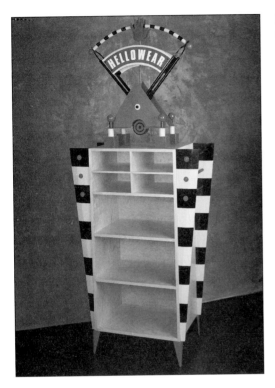

Fig. 1-11. Kilmer and Kilmer, Brand Consultants, point-of-purchase display. Hellowwear, 1998.

Key Words—Vocabulary for Study, Discussion, and Critique

1. Advertising design
2. Application
3. Architectural signage and environmental design
4. Book and publication design
5. Business communications
6. Content
7. Electronic communications
8. Film, video, and computer graphics
9. Form
10. Identity systems
11. Information and exhibition design
12. Packaging and point-of-purchase design
13. Propaganda
14. Social, cultural, and political communications
15. Visual communication

2 Parameters and Problem Solving

Every graphic design project has *parameters* that affect the designer's course of action. Parameters may include working with preapproved text and images; using prescribed materials and formats; producing the project on schedule and within the approved design and production budget; and fabricating the project according to production specifications. Some designers view parameters as *limitations* to their creativity, rather than accepting them for what they are; practical, agreed-upon boundaries that help focus attention on the client's communication objectives.

Graphic designers, working within the parameters of an assignment, solve communication problems. *Problem solving* is an intriguing and challenging aspect of design; the designer's creative and analytical resources are fully engaged, to unite assorted materials into a comprehensive whole. Designers are notoriously curious about the world and how it works, and they take great pride in crafting an engaging solution uniquely suited to their client's needs. On the artistic level, designers take immense pleasure in exploring the full range of visual media, from conventional, to digital, and beyond, searching for the perfect vehicle through which to express their client's message.

The successful designer takes the parameters others see as restrictions, and turns them into problem-solving attributes. Problem solving within parameters pushes the designer to see things from a new perspective, often resulting in a more exceptional design solution.

Until photographic reproduction processes were made practical in the early twentieth century, wood and metal *line engravings* were heavily used to illustrate such communications media as newspapers, books, magazines, and catalogs. Artisans laboriously engraved illustrations into the surface of wood or metal blocks, which were then assembled with type material, on the bed of a *letterpress*, and printed. By today's standards, one could see this process as tedious, primitive, and limiting. However, engravings from this period are incredibly beautiful, often demonstrating exceptional drawing ability and exquisite tonal range. Their strong line quality and delicate tonal

gradations are compatible with type, and print trouble-free, making them immensely popular with contemporary designers. Responding to the "limitations" of the print process of that period, resourceful illustrators and lettering artists raised the skill level of their profession to extraordinary heights, producing every conceivable kind of image **(fig. 2-1).**

Throughout the twentieth century, parallel with extraordinary advances in *offset* and *digital* print technology, there has been an unflagging appreciation of the tactile surface quality and graphic contrast of letterpress printing. Despite the labor and time-intensive skill requirements, a small cadre of designers and printers have found a niche market for *limited-edition* letterpress printing. Augmenting conventional nineteenth-century techniques and materials with twentieth-century computer and *polymer plate* technology, they produce rich and varied, handmade work, impossible to achieve by any other method. Paradoxically, considering the "antiquated" technology, much of this prestigious work is created for highly sophisticated or "alternative" clients, who appreciate the unique, handmade appearance and fine artisanship of limited editions.

A combined moving notice and business card, produced by Bruce Licher, for his Independent Project Press, displays the meticulously elegant typography, virtuoso exploitation of antique rules and borders, and intriguingly ambiguous images for which he is known **(fig. 2-2)**. The thick, *die-cut* and *perforated card stock,* and the *distressed,* grainy print quality lends a tough, blue-collar aura to the functional but delightfully decorative project. Licher's creativity, persistence, and highly refined technical skills enable him to

Fig. 2-1. Line engravings from trade catalogs, 19th and early 20th century. *Scan This Book Three,* John Mendenhall, Art Direction Book Company, 1998.

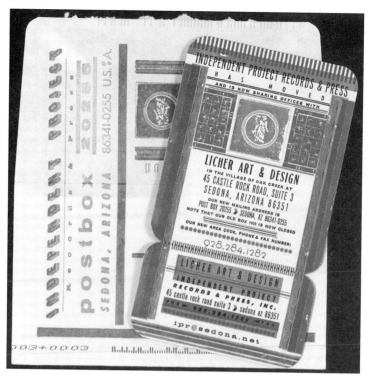

Fig. 2-2. Bruce Licher, moving notice and business card. Licher Art and Design, Independent Project Press, 2001.

transform what some designers would consider tedious production con-
straints into design advantages.

Lisa Graff also moved her business to a new location, announcing it with
a low-budget, *two-color* postcard **(fig. 2-3)**. For most designers, this kind of
project doesn't warrant a costly printing job. Therefore, the significant pa-
rameter is the constrained budget. The problem to be solved is how to cre-
ate effective communication without spending an excessive amount of money.
Graff, rather than resorting to elaborate two-color pyrotechnics, wisely
minimized the color effects, the form of the card determined instead by her
verbal/visual concept.

The horizontal card is divided into a nine-unit checkerboard, with alter-
nating grid units being either the white of the paper or olive green, one of the
two *spot colors* of ink. With a wry sense of humor, Graff spells things out for
the recipient; first, she directs the order in which the text is read, by sequen-
tially numbering each of the four essential text elements of the announce-
ment (she's moving, and she has a new address, a new telephone number, and
a new fax number). Second, she makes sure no one misses the point, by using
arrows to direct the reader's attention to her new address, telephone number,
and fax number. The *body copy* is neatly divided so that eight of the grid units

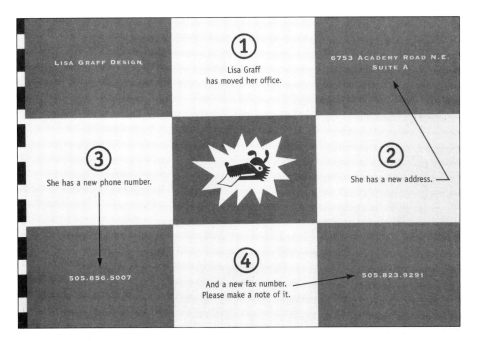

Fig. 2-3. Lisa Graff, postcard moving notice. Lisa Graff Design, 1998.

contain text, while the centrally located ninth unit houses an energetically de-
termined delivery dog, printed in black, the second of the two available col-
ors. Graff's solution focuses the reader's attention on *concept*, rather than
limitations, turning a routine assignment into an amusing diversion.

Screenprinting, like letterpress printing, imposes certain restrictions on
the type of artwork the designer can use. In photographic *screenprinting*,
used for graphic design projects, line copy *transparencies* of the artwork to
be printed are used to make extremely accurate *stencils*. A squeegee is used
by the printer to force ink through the processed stencil, which has been ad-
hered to a fine-mesh fabric stretched on a rigid screen frame. The ink is thus
transferred, through the mesh of the fabric, onto the paper or other sub-
strate. A separate stencil is made for each color to be printed. To make the
finished print, stencils are printed in succession, one color at a time, each
stencil carefully *registered* to the others. Photographic stencils respond best
to high-contrast line copy, such as coarse *halftones*, posterized photographs,
bold typefaces, and black and white graphic stylizations. A variety of papers
and other substrates can be used for screenprinting and the substantially
heavy ink layer allows light colors to be printed over dark.

Ronnie Garver took advantage of the distinctive visual quality of screen-
printing to accentuate the narrative content of his poster for the Mexican
holiday, *El Dia de los Muertos (The Day of the Dead)* **(fig. 2-4)**. The traditional
holiday is celebrated on November 1 and 2, at the same time of year as All

Fig. 2-4. Ronnie Garver, poster, *Dia de los Muertos (Day of the Dead).* Las Cruces Museum of Natural History, 1998.

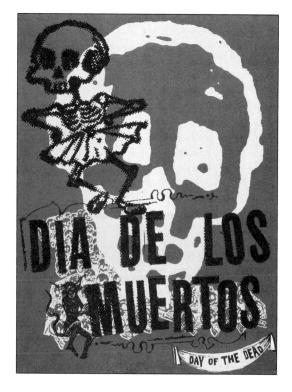

Saints' Day and All Souls' Day. The celebration honors the spirits of the deceased with joyful parades and home altars featuring skeletons and ghosts. Garver's animated use of extremely exaggerated halftones and layers of deliberately coarse images effectively expresses the festive atmosphere of the holiday, a lively acknowledgment of the folk art tradition. Bright, opaque colors are overprinted on the dark sheet, emphasizing an enormous, stylized skull, a ghoulish red devil, and an amusing skeleton in fancy dress. The high-contrast print medium, rather than being a limitation, proved to be perfectly suited for the job at hand.

The *space* in which a graphic design is to be displayed is a parameter that can affect the size, shape, and even the visual content of the final product. Paul Davis's theater poster, *For Colored Girls Who Have Considered Suicide/When the Rainbow is Enuf* **(fig. 2-5)**, was designed to be displayed in the cavernous, agitated space of the New York subway system. To establish a physical presence in such a competitive environment, the size of the poster, by ordinary standards, is enormous (81 × 41 in.!), and its narrow height-to-width proportion is exceptionally vertical (a ratio of approximately 2:1). Making Davis's poster even more conducive to its setting are the background tiles, faux mosaic letters, and painted script of his illustration, mimicking the actual mosaic signage, graffiti, and white tile walls of the subway itself. Davis responded to the challenging display space by adapting to it, recognizing

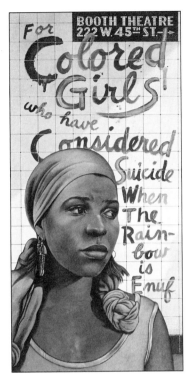

Fig. 2-5. Paul Davis. *Colored Girls.* Theatre poster, 1976. Art Resource, NY.

that the challenges were, in reality, a positive opportunity for him to create a memorable graphic gesture.

To communicate a particular message, many design projects require the use of very specific images. Although the designer can choose the form of the image, such as photography or illustration, he or she may have to work with existing pictures. In order to achieve success in this scenario, the designer has to find a way to transcend the nature of the resource material. Cisneros Design was asked to produce a fundraising brochure for El Rancho de las Golondrinas (Ranch of the Swallows), New Mexico's only living history museum **(fig. 2-6)**. Naturally, the brochure had to include photographs of the museum building and its surroundings, as well as employees, volunteers, and visitors. In ordinary hands, this type of project would be predictably bland, but Cisneros Design produced a handsome brochure of which the museum could be proud.

The brochure is simple in format (a single, gate-folded sheet), with warm *duotone* photographs and considerable text. Taking a cue from the sub-head, "Take a Journey to the Past," the designers first created a beautifully rhythmic and ruggedly weathered logotype for the museum. On the cover, the logo is nicely integrated with a photograph of the museum. The digitally roughened edges of the photograph blend well with the textured logo. The use of a script typeface together with a softly tinted image of a swallow evokes the

Fig. 2-6. Cisneros Design, brochure. El Rancho de las Golondrinas (Ranch of the Swallows), Santa Fe, New Mexico, 2000.

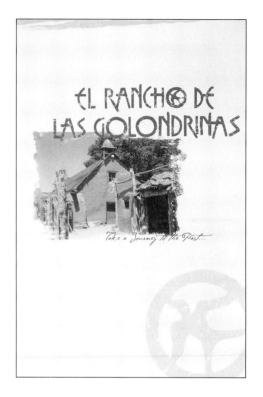

Spanish colonial atmosphere of old New Mexico. The generous use of negative space, the delicate warmth of the duotones, and the discreetly sized body copy contribute to the overall success of the project. Working with a few nice photographs, a well-designed logo, and tasteful typographic form, Cisneros Design did well by its client.

The parameters for *corporate identity systems* relate not only to content and appearance, but also to application and distribution. The identity mark is the key element of an organization's *business communications program*, establishing their public image by means of consistent visual treatment over an extended period of time. To ensure the proper use of the symbol or logotype, the designer often produces a *graphic standards manual*, describing exactly how the mark and its accompanying typography are to be applied. Like all identity marks, the logotype Kilmer and Kilmer, Brand Consultants, created for Holusions, a holographic illusion poster company, had to perform in a variety of typical situations **(fig. 2-7)**. Because identity marks are destined for reproduction using a variety of media, with varying budget constraints, they have to be reproducible in black and white, as well as in color. Additionally, because they are used in a variety of formats, from business cards to architectural signing, they have to be readable in a wide range of sizes, and compatible with accompanying typographic material. Adaptability is crucial because business

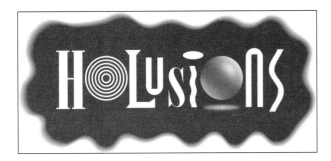

Fig. 2-7. Kilmer and Kilmer, Brand Consultants, corporate identity mark. Holusions, 1992.

documents are also copied, faxed, and integrated into electronic applications such as web sites, and even used on packaging, displays, vehicles, and uniforms. Understanding the particular parameters and problem-solving aspects of identity systems and accompanying *collateral materials* is critical, because these projects are the "bread and butter" of many design firms.

Sometimes a project's content is so specific and unique that it defines the parameters for both the creative design solution and the handling of media. The catalog cover for Eliza Tinsley and Company, Limited, of Great Britain, shows how form and content can be fused in response to project parameters **(fig. 2-8)**. Catalog covers typically illustrate the products being merchandized. In this case, the company made galvanized hollowware, items such as buckets, cans, sprinklers, pots, and pans. The cover was screenprinted (called "silkscreening" at the time of this project, because the screen fabric was made of silk rather than the synthetic fabric used today), *embossed,* and silver *foiled* to emulate the appearance of the company's utilitarian products. Light-on-dark printing, embossing, and silver foil create an illusion of volume on the flat surface of the cover, while the sophisticated design and production standards convey an impression of well-made, quality goods. The designer tightly integrated exotic graphic art processes, fully realizing the communication goals of the project.

In a similar vein, a folder created by Cisneros Design, for artist Dan Naminga's exhibition, *Structural Dualities,* takes its form from the title, shape, and structure of the artist's work **(fig. 2-9)**. The flat sheet of cover stock is die cut, creating a piece that can be folded into a three-dimensional "mini art gallery" that echoes the geometrically contoured shapes of the paintings.

Likewise, the interior layout of the book, *Reflections on Golda,* published on the 100th anniversary of the birth of Golda Meir (prime minister of Israel from 1969 to 1974) is appropriately designed in the shape of the sacred symbol of Judaism, the six-pointed Star of David **(fig. 2-10)**. The book pages, formed by the overlapping of two triangles, embody a perfect correspondence between form and content, echoing the Star of David's elemental structure. Produced in New York by Purgatory Pie Press, the book features the

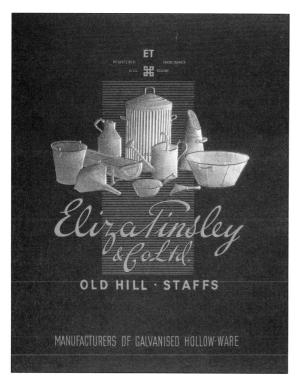

Fig. 2-8. English Catalogue Cover.
Silkscreened, embossed, and matt silver
foiled. Eliza Tinsley & Co. Ltd., Staffordshire. c.
1935. Victoria & Albert Museum, London / Art
Resource, NY.

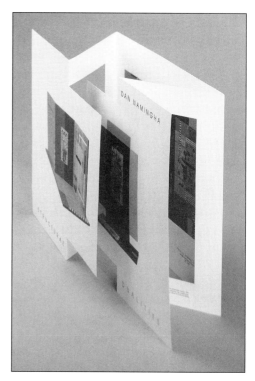

Fig. 2-9. Fred Cisneros, Cisneros Design,
brochure, *Dan Naminga, Structural Dualities.*
Wheelwright Museum of the American
Indian, 1997.

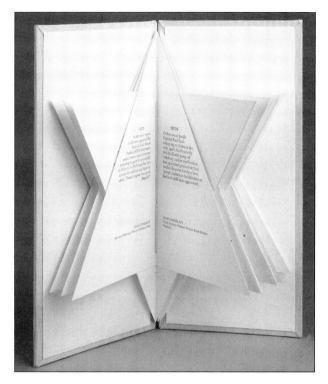

Fig. 2-10. Star book structure and binding designed by Esther K. Smith, Carol Hamoy, interior graphic design, Dikko Faust, letterpress printing from monotype, respaced by hand, *Reflections on Golda,* 1998.

meticulous typesetting, fine presswork, and innovative bookbinding for which they are so well known.

Retail *packaging* is another area with very particular parameters. Obviously, a package is meant to contain something, and so the designer has to design within the parameters set by the size and shape of the object to be contained, as well as by such factors as print technology, material and fabrication techniques, storage and point-of-purchase display provisions, and shipping requirements.

The package designed for Baby Tree by Lisa Graff, of Vaughn Wedeen Creative, had particularly interesting requirements **(fig. 2-11)**. The product was called "Baby Tree" in reference to the ancient tradition of planting a tree when a child is born. Inside the small box is a miniature flowerpot of peat, containing several specially treated seeds in a bed of moss. Accompanying the pot is a tiny booklet containing planting instructions, tree lore, and general information about trees and conservation. The package, fabricated from organic and recyclable (or recycled) materials, is sturdy enough to protect the flowerpot, and has sufficient size to contain both the pot and the booklet. The client's commitment to environmental education, recycling, and the planting of trees is pleasantly communicated via the package's illustration style, color palette, and typographic design. The assignment reaffirms not only the tremendous diversity to be found in the graphic design profession,

Fig. 2-11. Lisa Graff, Vaughn Wedeen Creative, package design, *Baby Tree.* Datil Mountain Evergreen, 1993.

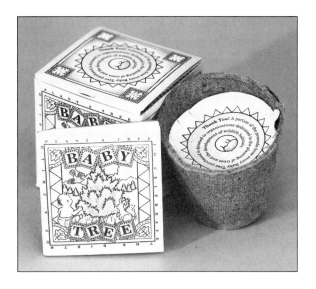

but also the ability of the successful designer to respond to each project with intelligence and creativity.

Key Words—Vocabulary for Study, Discussion, and Critique

1. Body copy
2. Business communications
3. Card stock
4. Collateral
5. Concept
6. Corporate identity systems
7. Die cut
8. Digital print technology
9. Distressed
10. Duotone
11. Electronic media
12. Embossing
13. Foil stamping
14. Graphic standards manual
15. Halftone
16. Letterpress
17. Limitations
18. Limited edition
19. Line engraving
20. Offset lithography
21. Packaging
22. Parameters
23. Perforated
24. Polymer plate
25. Problem solving
26. Registration
27. Screenprinting
28. Space
29. Spot color
30. Stencil
31. Transparency
32. Two color

3

The Design Process

Graphic design is an active process. On the most fundamental level, designers are creative problem solvers; working within time constraints and an established budget, they employ an almost universal *design process* as a means by which to generate effective communications solutions **(fig. 3-1)**. Paradoxically, the creative aspect of the design process is driven by the tension that exists between client constraints and personal expression. In responding to the challenges posed by each project, designers must use their full complement of imaginative and analytical skills. Although the *process* of making design is certainly rewarding in itself, a greater degree of personal satisfaction is attained when the needs of the client, the target audience, *and* the designer intersect at the highest level.

Planning and Preliminary Negotiations

Communication projects are usually initiated by the client, often in-house, and frequently long before designer involvement. In attempting to articulate a precise definition of the communication problem, projects usually begin with data gathering, market comparisons, and research and analysis. In the most positive scenario, a general *communication strategy* is established by the client and supported by key personnel. When the strategy indicates the need for a design professional, the search for a designer is initiated. Designers can be chosen based on the quality of their *portfolio,* by referral or reputation, or simply based on past performance. Following one or more meetings, the designer is usually asked to make a *proposal,* which includes a generalized creative approach and a *cost estimate.* Before beginning design work, *contracts* or *letters of agreement* must be signed, stipulating *timetables, payment schedules,* and a precise description of the project. Professional organizations such as the *Graphic Artists Guild,* the *American Institute of Graphic Arts* (AIGA), and the *American Center for Design* publish invaluable guidelines to assist the designer with ethical, contractual, and business matters. Contractual

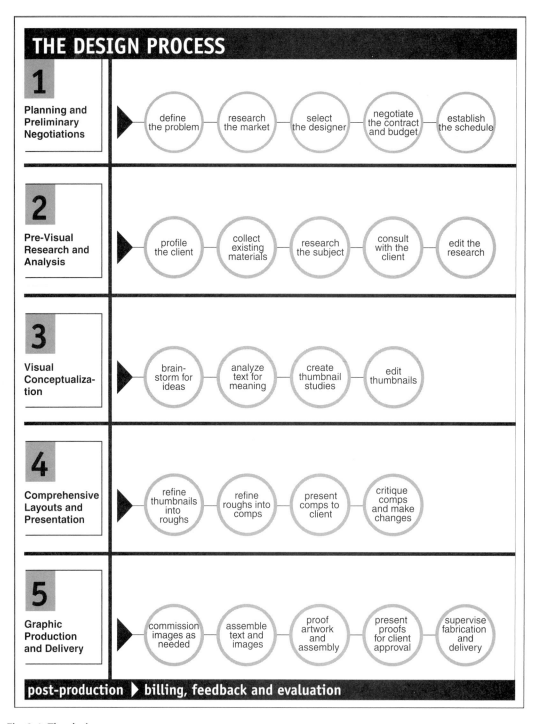

Fig. 3-1. The design process.

agreements made during the preliminary stages of a project will significantly influence the comfort level of the process as well as the ultimate outcome. Finally, at the very inception of the project, to enable everyone to work efficiently and with trust, the client and the designer must identify a contact person and final decision maker.

The communication skills required during the *previsual* stages of a project are different from those needed later. The ability to write proposals, letters of agreement, reports, and other kinds of business documents is a critical skill not to be taken lightly. Likewise, designers use their verbal skills to rationalize their creative ideas during presentations and other business situations. Literacy is, of course, a powerful tool for communicating with nondesigners.

Previsual Research and Analysis

When the client is new to the designer, a good first step is to develop an understanding of who the client is, what the company does, and where it's positioned in relation to others in the field. Visiting the client's offices, retail outlets, manufacturing facilities, or working space provides a more complete understanding of the business or service. To help shape the profile, the designer collects the client's previously designed materials and looks at materials being produced by competitors or related organizations. Depending on the sophistication of the client's business *methodology*, a considerable body of useful research may already exist within the organization. Patience and thoroughness are valuable attributes during the previsual stage of any project. As early as 1966, Ken Garland, in *Graphics Handbook*, suggested that graphic designers were in danger of becoming obsessed with technique rather than communication, advising designers to methodically collect, classify, and select materials that will help them understand the meaning of the message to be conveyed.

In addition to working directly with client-based materials, many other research avenues such as the library, visual resource services, and the Internet should be explored. In the early phases of a project it's advisable to keep all options open, avoiding, if possible, preconceptions or clichéd thinking. Research should be approached as a creative process of discovery, rather than a boring necessity. The excitement of finding just the right piece of information, or the perfect visual resource, is one of the rewards of this kind of work. The tone and general direction of a project is established (sometimes subconsciously) during the research stage of the design process.

When an adequate amount of material has been gathered, the designer begins the *editing* process, sifting through the raw data, selecting the most promising and appropriate images and texts with which to work. Feedback from the client is important when evaluating research materials, to ensure accuracy of information (such as choosing the correct historical period, the right costume, accurate financial data, or the proper microscopic scan) as

well as the appropriateness or relevance of your decision making. Among the other considerations influencing decisions made at this point is an understanding of *copyright laws* that may affect the usability of certain research materials. The *Graphic Artists Guild Handbook: Pricing and Ethical Guidelines* is a valuable resource for this kind of information.

Visual Conceptualization

Once the communication problem has been stated and resource materials have been gathered, the designer begins to conceptualize a solution. There are many ways to begin working with the data gathered during the previsual period. There is almost certainly a *brainstorming* period, during which ideas are put forward in a free-flowing, nonjudgmental manner. This is a spontaneous practice; ideas are jotted down as they come and doodles serve to augment words. The primary goal is to quickly generate a diverse range of ideas.

If there is difficulty in getting started, there are useful techniques to augment conceptualization. Taking the design of a book cover as an example, there are simple techniques to begin unearthing ideas. If the book title or content is already pictorial, the approach may be as simple as visually representing the title or the subject. "The Bird, the Sky, the Sun, and the Moon" is an example of a pictorial title (the title suggests pictures). "150 Birds of the Desert Southwest" is an example of a book with pictorial content (the title describes the specific content). Obviously, the designer is going to research birds, the sky, the sun, and the moon in the first instance, and specific birds of the desert Southwest in the second.

If the book is not so obviously pictorial, a thorough *text analysis* of the title and content may prove fruitful. For example, a systematic dissection of the title, "Megalopolis: The Paving of Rural America," will result in a useful list of potential design ideas.

Megalopolis:

megalo: large or great
polis: a city (Greek)
megalopolis: a grouping of adjacent cities and their surrounding areas, perceived as a single urban unit

Paving:

paving: the material used to pave a surface, or the laying of pavement
pave: to cover a surface with a smooth, hard material suitable for travel
pavement: a durable, smooth material used to make a road or a sidewalk

Rural:

country: the outlying area of a city or town
farming or agricultural land
farmers or country people
natural
undeveloped

America:

The United States of America
The Americas: North and South America, or the Western Hemisphere

From this master list of terms, more comprehensive sublists may be freely extrapolated:

Megalopolis/Paving: city, urban, networks, people, concrete, freeways, streets, density, automobiles, parking lots, signs, skyscrapers, etc.

Rural/America: open country, farms, farmers' fields, rolling hills, trees, crops, farmers, tractors, country roads, main street, animals, sunrise, sunset, rivers, etc.

This simple exercise provides numerous possibilities for visual exploration. For example, it's immediately apparent that there's an interesting visual contrast between the intensely developed megalopolis and the open country of rural America. By selecting image pairs from each list (such as "parking lots" and "farmers' fields," or "automobiles" and "crops") a dynamic and meaningful graphic image can be developed. The same procedure that was applied to the title can also be applied to appropriate text passages from the book, yielding even more possibilities.

The object of brainstorming is to discover a potent *graphic motif* that serves as a vehicle for content. During the design process, it's important to question your choices. Is the motif readable? Is it relevant? Is it meaningful? Is it intriguing? Is it surprising? Is it smart? Is it beautiful? Is it ugly? Is it exciting? Do you like it? Are you excited to work with it? Of course, at this stage, design decisions are not based on logic and research alone. Intuition and personal esthetics should also be allowed to affect the process.

After a number of viable ideas have been accumulated, the designer starts to make initial sketches. These small studies are called *thumbnails,* and their quality is dependent on the drawing ability of the designer. Thumbnails are usually for the designer's eyes only, and aren't seen by the client **(figs 3-2, 3-3)**. Because they're used to test very general concepts and visual relationships, thumbnails are very broad in form. Primary tools such as marking pens, ballpoint pens, graphite, and layout paper are often used, deliberately limiting detail and finish. If the designer is working in a *studio,* or is somehow affiliated with other designers, thumbnails can be shown to trusted colleagues. Whatever the editing process, only the best ideas are chosen for further development.

Comprehensive Layouts

The next step in the process is to work up *roughs* or *comps (comprehensive layouts)*—larger, more complete representations of the best ideas **(fig. 3-4)**. Again, a variety of tools and techniques are used. Some designers prefer to continue drawing the image, refining the form, and testing the concept. Others prefer scanning the thumbnails and then using a computer graphics program to perfect the image (see fig. 3-3). Depending on the concept and the

Fig. 3-2. Preliminary notes, research materials, and thumbnails.

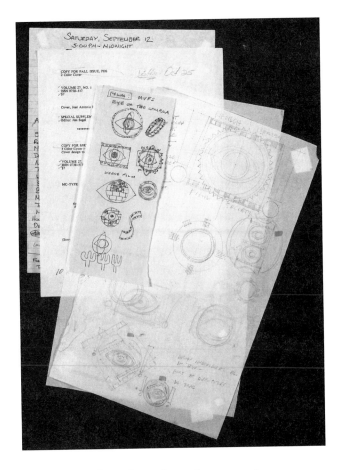

final reproduction or delivery method, tools such as the computer, scanner, process camera, copy machine, and desktop printer may be used. Work destined for the Internet can be previewed in a browser or web design program **(fig. 3-5)**. Comps are important for several reasons; (1) they're presented to the client for discussion and approval; (2) they establish the conceptual direction of the project, and (3) upon acceptance, the designer receives a percentage of his or her fees, and authorization to move on to the next phase of the assignment. Because comps are so critical, they are typically supported by a verbal and, occasionally, written rationalization. The ability to present your work visually, verbally, and in written form is crucial to success in the design profession. A designer should have the creative, intellectual, and technical versatility to use whatever means are required to make a successful presentation.

During the meeting at which comps are discussed, the client is expected to ask probing, difficult, and perhaps even critical questions about the work. Not surprisingly, designers as a rule become attached to the ideas they have worked so hard to produce, and criticism may be hard to accept. However,

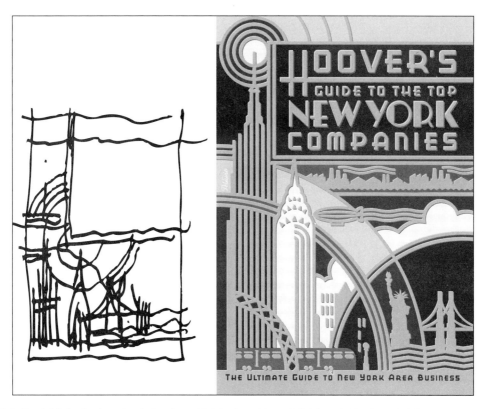

Fig. 3-3. Daniel Pelavin, thumbnail sketch and finished art, *Hoover's Guide to the Top New York Companies,* 1996.

Fig. 3-4. Rough and comprehensive layouts.

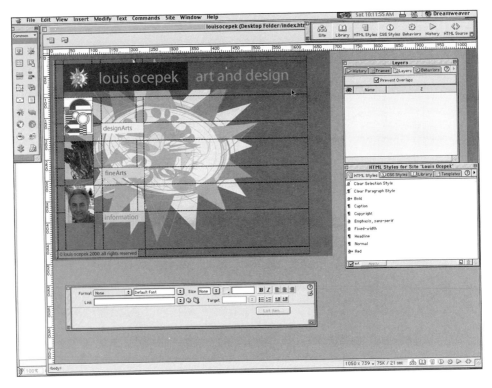

Fig. 3-5. Preview of web site.

depending on their character and sophistication, it is advisable to view the client as a resource and collaborator, rather than an adversary. The client may have valuable insights and a unique point of view that can improve the quality of the project. A flexible attitude, the willingness to participate in open discussion, and the courage (and verbal ability) to stand up for your ideas are required. Changes are almost inevitable, but they need not be feared.

Graphic Production

The *graphic production* phase of the design process involves the creation of *finished art*, which incorporates any changes agreed upon in the comp stage. Production is critical to the success of the project, and many designers consider it as crucial as the earlier, more creative stages of the design process. Designers take pride in their ability to produce exactly the artwork they need, employing a wide range of tools, media, and techniques.

Finished art varies in form depending on whether the art is for print or electronic delivery. It can be *original art,* a conventional *mechanical,* or a *digital file* **(fig. 3-6)**. During the production stage, the designer assembles all the text and image components that make up the final product. Some

Fig. 3-6. Finished art and elements of graphic production.

components, such as photography, illustration, and custom lettering, may have to be commissioned from specialists, and cost estimates or bids are obtained from suppliers and service bureaus. The *service bureau* produces the high-resolution *proofs* and film needed for final approval by the designer and client. (See chapter 16 for a further discussion of graphic production.)

Finally, the designer's studio work is done. However, there are responsibilities that extend beyond the studio. Once the designer's production work is completed, it's passed on to the professionals responsible for fabrication (such as printing and binding) or electronic delivery via the Internet. The designer is responsible for seeing that suppliers complete their work according to specifications, within the budget, and on schedule. Print projects require extensive *prepress* and *press proofing,* supervised and ultimately approved by the designer, acting for the client. Electronic projects, such as web sites, must be proofed and tested before going online.

Postproduction

After the work is delivered, bills must be paid, invoices issued, and a final meeting with the client may be in order to discuss outcomes and, hopefully, a new project. More sophisticated clients gather feedback on their latest communications via market research, which may be shared with the designer. For the designer, there is an ethical responsibility to the client (and oneself)

to do the best work possible on every project, tackling each one with equal commitment and professionalism. On the practical level, each project represents an opportunity to generate not just more work, but work of better quality. To continue to grow in the profession, it's helpful, at the conclusion of an assignment, to evaluate not only the final product, but also the design process, looking for opportunities to improve one's design methodology.

Key Words—Vocabulary for Study, Discussion, and Critique

1. American Center for Design
2. American Institute of Graphic Arts
3. Brainstorming
4. Communication strategy
5. Comp
6. Contract
7. Copyright law
8. Cost estimate
9. Design process
10. Digital file
11. Editing
12. Finished art
13. Graphic Artists Guild
14. Graphic motif
15. Graphic production
16. Letter of agreement
17. Mechanical
18. Methodology
19. Original art
20. Payment schedule
21. Portfolio
22. Prepress proof
23. Press proof
24. Previsual
25. Proposal
26. Rough
27. Service bureau
28. Studio
29. Text analysis
30. Thumbnail
31. Timetable

Point of View and Attitude

Creating work that satisfies the artistic and spiritual needs of the designer, while meeting the demands of the marketplace, is one of the challenges that makes the graphic design profession interesting. Those projects that capture the audience's imagination, standing the test of time, transcend the original assignment and embody the designer's personal stamp (or point of view). Of course, requirements vary from project to project. Not all clients are enlightened regarding the value of good design, and some projects may have constraints that restrict creativity.

Graphic designers, like fine artists, try to express their point of view in a manner that is esthetically appropriate and personally satisfying. However, because graphic design is visual communication, the designer must, of course, address the legitimate needs and objectives of the client. Designers must be adept at producing effective work within budget and on time. Therefore, while every graphic design project reflects the designer's point of view, his or her interpretation is almost always tempered by parameters. To address the needs of each client, graphic designers must be versatile and well versed in graphic communication strategies.

Point of view is the conceptual position adopted by the designer following a thorough analysis of the area under discussion. *Attitude* is closely related to point of view, but relates more to personality than to intellect. Attitude is a more self-conscious and emotional expression of the designer's personal tastes and prejudices, esthetic and otherwise. Design projects have different personalities, much the same as individuals do. Designs that have a definitive personality are proactive and more likely to effect change. When the designer works with passion as well as intelligence, graphic design will have both point of view *and* attitude.

Point of View

Graphic design projects for social, political, or cultural organizations often offer the most creative latitude. Many designers are themselves activists and members of the larger cultural community, so it's natural that they include this

kind of work in their client base. Public institutions, like businesses, need to establish an identity and attract an audience, so they too have a need for graphic design services. It's important to remember that even nonprofit organizations often have graphic design budgets, although designers frequently donate their services to causes they believe in. It's very possible, and commendable, to perform *public service* while still making a living. In 1964, British designer Ken Garland published the manifesto, *First Things First,* proposing more involvement by designers in socially responsible design projects. In 2000, *First Things First 2000,* an update of the original manifesto, was published and later endorsed by hundreds of contemporary designers, including Garland.

The propaganda poster by Karl Koehler and Victor Ancona, *This is the Enemy,* was designed in 1942 for a National War Poster Competition **(fig. 4-1).** There is no doubt about their viewpoint regarding the subject. The poster concept is very simple and to the point. A Nazi officer is portrayed in full dress uniform, precisely rendered, aloof, cold and impersonal, his features distorted to make him (and, by extension, all Nazis) ugly and despicable. Reflected in his monocle is an execution by hanging, making his demeanor even more dangerous and revolting. Obviously, the designers have applied their talents to a cause they believe in. The competition (sponsored by Artists for Victory, Inc., the Council for Democracy, and the Museum of Modern Art) was created to encourage the production of posters that could be used to counter antiwar

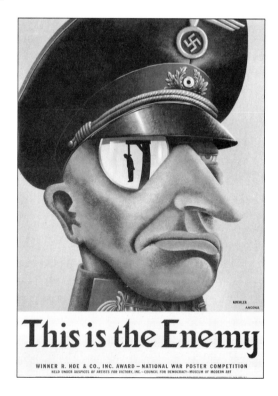

Fig. 4-1. Koehler, Karl and Ancona, Victor. *This is the Enemy.* 1942. Smithsonian American Art Museum, Washington, DC / Art Resource, NY.

sentiment during the early days of the Second World War. As is always the case during times of war and other national crises, the graphic design profession was called upon to influence public opinion and move people to action.

The desert Southwest is often thought of as an inhospitable, forbidding place. Indeed, to those speeding through on the interstate highway, it may appear to be lifeless and without redeeming geographical features. For those who know the desert, the reality is quite different. Chad Ballard's poster for the Symposium on Resources of the Chihuahuan Desert **(fig. 4-2)** succeeds in portraying the desert as a truly rich and diverse environment. Like many posters for academic events, this poster is *copy heavy*. To accommodate and organize the large quantity of text, Ballard divided the tall, narrow *format* into three unequal panels. Specifics (such as the title of the symposium, dates, location, and contact information) are placed in the top and bottom panels, sharing a common typeface and color treatment. The session topics occupy the central panel, in a different, reversed-out typeface. The quality of the typographic design alone sets this poster apart. The designer's attention to detail lends credibility and significance to the event. It looks "professional." Ballard uses the elegantly sculptural (and somewhat sinister) seedpods of

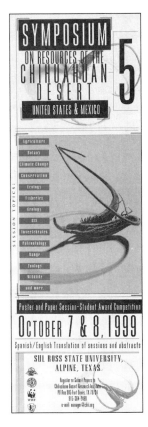

Fig. 4-2. Chad Ballard, poster, *Symposium on Resources of the Chihuahan Desert.* United States and Mexico, Chihuahuan Desert Research Institute, World Wildlife Federation, 1999.

the devil's claw plant to represent the harsh beauty of the Chihuahuan Desert. The beautifully detailed typographic design, the artistic treatment of the images, and the restrained color palette contribute to the projection of a positive point of view.

In a limited-edition poster, *Bars and Stars,* René Galindo, a designer from Mexico City, expressed his strong views regarding the plight of Mexican immigrants working in the United States **(fig. 4-3).** Certain graphic *icons* (such as the American flag, the swastika, or the cross) engender emotion by association with events, institutions, or belief systems. Designers describe these images as being *"loaded,"* or *"charged."* It's almost guaranteed that they will evoke a response of some kind from the audience. Galindo, looking for an image powerful enough to carry his message, decided on the American flag. To make his political point, he replaced the flag's conventional red stripes with bars of red text, overprinted on a posterized image of a farm worker. (Notice how the text in each bar was perfectly spaced to maintain the rectangular shape of the flag.) Widely letterspaced, reversed-out text was used to replace the white stars normally found in the flag's blue star-field. The poster was *screenprinted* using opaque inks, ensuring a brilliant color palette and the complete *overprinting* of the figure. The accumulated image manipulations cause the reader to consider the meaning of the American flag from a contrasting point of view, not

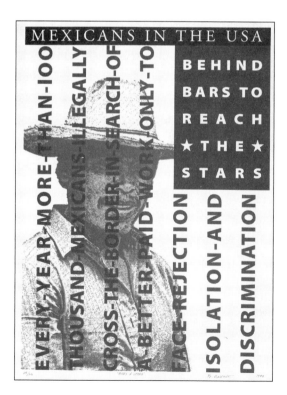

Fig. 4-3. René Galindo, poster, *Bars and Stars.* New Mexico Center for the Graphic Arts, Art Department, New Mexico State University, 1999.

only as a traditional symbol of freedom and independence, but, ironically for some immigrant workers, as a symbol of imprisonment.

Issues themselves, as well as images, can trigger a reaction. To create meaningful graphic design about a charged issue, the designer must have a good understanding of the subject. Loaded issues have already received heavy media attention; the people who care about the subject will have prior knowledge and will scrutinize the work closely. Therefore, each aspect of the design must be carefully considered. Once the work is distributed to the public, particularly in *print*, it's too late to make changes.

Cuba is an example of a highly charged issue, the result of a long history of political and economic conflict with the United States. The author designed the cover of a special issue of the literary journal *Puerto del Sol* devoted to Cuban poetry **(fig. 4-4).** After discussing the assignment with editor in chief Kevin McIlvoy, he began to do research on the general subject of Cuba, so he would have an informed point of view. After discarding material that seemed unworkable or irrelevant, there remained several ideas that had either visual or conceptual potential. The goal was to integrate the visual and conceptual ideas into a comprehensive design that communicated a balanced point of view.

The final design can be *deconstructed* into its component parts, to show how they were interrelated. The style of the cover was meant to be dramatic.

Fig. 4-4. Louis Ocepek, book cover, CUBA. *Puerto del Sol,* New Mexico State University, 2001. Photography, Kathleene West.

A frame on three sides of the cover creates a deep central space containing several clearly articulated elements. The largest element is a stylized exclamation mark, angled from upper left to lower right. The exclamation point "exclaims" the importance of the subject while creating visual tension. A photograph of a young woman is cropped into the upper part of the mark; emerging from the dark, she symbolizes the future, her smile reminding the reader that not everything about Cuba is negative. The bottom, rounded segment, is a red-hot, stylized sun, symbolizing the emotional and political heat of Cuba (Cuba is a "prickly" problem for the United States). The sunlike shape also symbolizes the geographic "island" of Cuba, floating in a sea of color. The angle of the exclamation mark places the island in the southeastern corner of the book, marking Cuba's geographical location relative to the United States.

A simplified map of the island and the word *CUBA* are positioned on either side of the exclamation mark, pointing inward, toward the hot island/sun. The initial letter *C* of Cuba is drawn in a decorative style reminiscent of Cuban folk art. The remaining letters of the word *Cuba* are set in black typographic caps, outlined in red to resemble the type style used on political posters of the 1950s and 1960s. The letters decrease in size from left to right, creating the impression that the letters are marching into the cover from the right-hand side, from over the horizon and across the Atlantic Ocean. This subtle manipulation of scale symbolizes the bringing of slaves from Africa to the Caribbean. This analysis shows how the designer employed selected graphic elements in a calculated arrangement (or *layout*) to illustrate a comprehensive point of view.

Kilmer and Kilmer, Brand Consultants, is a company whose goal is to help its clients improve business through strategic planning and creative *advertising* and design. It has established a proprietary process, named the Brand Building Blueprint™, that identifies the strengths and weaknesses of a company, while mapping out a plan for improvement. For the annual report of a company providing specialized, affordable pharmaceutical care to people with HIV and AIDS, Kilmer and Kilmer wanted to communicate its client's uniquely compassionate point of view **(fig. 4-5).** To achieve this objective, the company fashioned a dramatic layout style utilizing bold headlines and illustrations. One spread proclaims, in large sans serif caps, "MIX BUSINESS WITH COMPASSION." The accompanying illustration, a cropped section of George Washington's engraved portrait from a dollar bill, acts as a metaphor for business, civic responsibility, and profit. To complete the thought, a symbolic red ribbon, as worn by AIDS activists, is pinned to Washington's coat. Normally, the public does not associate compassion with business; profit making and compassion seem incompatible. The designers' job was to convey this client's unique business philosophy to shareholders and potential investors.

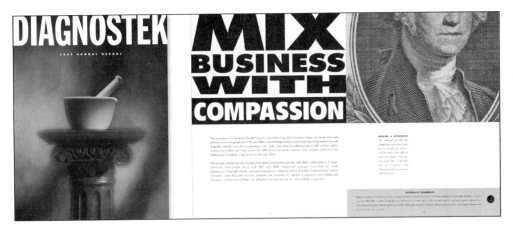

Fig. 4-5. Kilmer and Kilmer, Brand Consultants, annual report. Diagnostek, 1994.

The philosophy of *Constructivism* fueled El Lissitzky's design for a mechanical theater **(fig. 4-6).** Lissitzky, the Russian designer, painter, photographer, and architect, is a pioneering figure in the history of twentieth-century art and design. An enthusiastic supporter of the Bolshevik Revolution of 1917, Lissitzky's work was imbued with the idealistic spirit (point of view) of

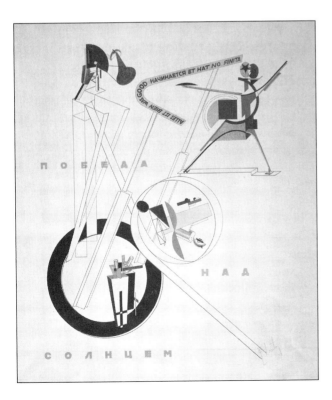

Fig. 4-6. Lissitzky, El (Eleazar), *Victory over the Sun: The Announcer,* 1923. Tate Gallery, London / Art Resource, NY.

the time. The Constructivists helped "construct" the new Soviet Union by turning their artistic talents to practical activities that were beneficial to society. In 1913, Alexei Kruchenych wrote a *Futurist* opera, "Victory over the Sun," in which the technical mastery of humans enables them to control their universe, supplanting even the power of the sun. In 1923, El Lissitzky designed the sets for a new production of the opera. He created a complex, electric-powered scaffold, the Spectacle Machinery, upon which *archetypal* characters played out various aspects of life. As befits the idealistic concept, Lissitzky's mechanical design is exquisitely fabricated of industrial materials and stripped of unnecessary shapes or lines. Modern Man, the Shaper of the Spectacle, uses light, sound, and movement to control the structure as it floats in a neutral, uncluttered space. Lissitzky's work is a *visual metaphor* of the ideal new world promised by the Revolution.

Attitude

Some projects resonate with their intended audience by reflecting the audience's attitude or mind-set. To make an image that projects the proper attitude, the designer must become familiar with the audience's personal tastes and prejudices through research or observation. Ronnie Garver is the graphic designer for University Communications at New Mexico State University. Each year, working closely with the Publications Section and the Admissions Office, he designs a university *View Book* that is widely distributed to high school students potentially interested in applying to the university **(fig. 4-7).** When institutions such as universities hire a *publication designer,* they look for someone whose *portfolio* demonstrates his or her ability to produce work that will address the many needs of their constituencies, which include prospective students, enrolled university students, faculty, staff, alumni, and administration. Because the specific *target audience* for the *View Book* is narrowly focused on high school seniors, the look of that particular publication must appeal to their style and attitude. The objective, in this case, is to assure them (and their parents!) that NMSU is a quality educational institution, located in a beautiful place, with a comfortable and exciting lifestyle.

Garver addresses these objectives through an energetic *design style* attractive to high school students. To achieve this style, Garver created a wildly *kinetic* layout, different on every *spread,* but linked by a similarity of color and typographic design. The spreads overflow with radically enlarged type (distressed by repeated copying), dynamically cropped photographs, and flat, vibrantly colored shapes. His personal design style shows a rich variety of influences: the untutored *vernacular design* of the street; the rough, irreverent graphics created by grunge bands of the 1990s; the bold experimentation of *Russian revolutionary design* of the early twentieth century; and the textured irregularities of nineteenth-century wood type. The design

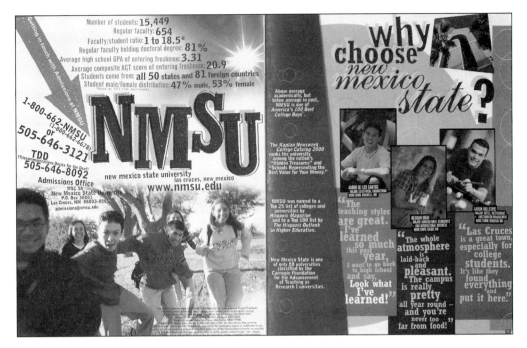

Fig. 4-7. Ronnie Garver, publication design, *View Book*. University Communications Office, New Mexico State University, 2000.

style portrays the university as a dynamic place, one that balances a solid educational experience with an exciting social life.

There are occasions when the client's message is so specific that the designer has to adjust his or her personal style for the sake of clear communication. In its annual report, Lasertechnics, an information transfer and management product company, wanted to communicate its "Back to Basics" attitude adopted by management to return the company to profitability **(fig. 4-8).** For designers Vaughn Wedeen Creative, this required what could be described as a "designing down" process. Rather than create a lavish (and expensive) report that made the company look prosperous and flush, or a report that was simply a showcase for their talent, the designers deliberately produced a plain-looking but highly functional book. To accomplish this, the designers utilized limited color, recycled paper, neutral sans serif headlines, and succinct, matter-of-fact copywriting. The content is addressed directly to the shareholders; on one page is a declarative statement or question, and on the facing page is the response. The writing style is easy to understand and to the point, straight talking with no frills. Ironically, rather than resulting in a dull and boring report, this low-key, but risky, approach resulted in a report admirable for its smartness and air of self-discipline. It communicates an attitude of responsibility, restraint, and sensitivity to shareholders' concerns, serving the client well.

Fig. 4-8. Vaughn Wedeen Creative, annual report, *Are We Still on Track?* Lasertechnics, 1995.

There is always a segment of the graphic design profession engaged in *experimental* or *theoretical* work that deviates from the norm. This extremely important activity results in work with an unfamiliar, sometimes radical form, not immediately acceptable to *mainstream* clients. Ultimately, of course, the mainstream gets on board, absorbing those parts of experimental work that can be put to practical use. Thus, the look of graphic design is changed and the cycle continues. A natural environment for experimental work is in the *counterculture,* where the limits of creativity are always being tested, and where having an "edgy" attitude is a good thing. Projects for these venues usually have a limited budget for design and production, but in exchange, they offer the opportunity for personal expression.

Rhony and Shad's poster for the resident dance company at New Mexico State University is an example of a modest work that deliberately blurs the line between *"good"* and *"bad" design* **(fig. 4-9).** The dance company wanted to project an exciting, energetic image that would help build an audience and generate ticket sales. The designers were given typical poster copy and still photographs, and it was their job to take the raw material and create something with attitude. Their visual approach was driven by their involvement with the club scene, alternative music, and a desire to challenge some

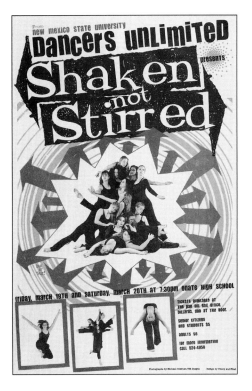

Fig. 4-9. Rhony and Shad, poster, *Shaken, Not Stirred.* Dancers Unlimited, New Mexico State University, 2000.

of the "rules" of *formal design.* Using the title of the performance, "Shaken, not Stirred," as their key, they created a take-off on the James Bond/Avengers image of the 1960s and 1970s. The *retro style* arrows, the vortex, the mix of type families, the tilted layout, and the cheap color all contribute to the campy *visual pun.* By expertly playing around with design conventions, Rhony and Shad were able to achieve the lounge-look/action-poster they were after. Significantly, because they were already comfortable with the fundamentals of formal design, they were able to break or at least bend the rules, while maintaining the necessary level of communication.

Jeff Neumann's intriguing visual metaphors give the entertainment tabloid, *Ticket,* a powerfully engaging presence. For an issue featuring concert previews of the "shock rock" bands Hole and Marilyn Manson, Neumann's *editorial position* was that these bands were no longer shocking **(fig. 4-10).** To present this concept visually, he contrived an evolutionary chain of mutating fruit flies as a metaphor for the weakening of the shock rock lineage. His cover design, appropriate to the subject, employs imagery that's unpleasant and mildly shocking (particularly for a daily newspaper): a hanging Marilyn Manson overlapped by a huge line-art image of a fly. The association of flies and a hanging with shock rock seems entirely appropriate. Coincidentally, the diagram of softly colored, mutating flies provides a geometric structure that organizes the layout and acts as a

Fig. 4-10. Jeff Neumann, cover design, *Shock Rock. Ticket, The Seattle Times,* 1999.

counterpoint to the large, amorphous central image. Neumann's editorial position gives the cover a point of view, and his aggressively nasty graphic image gives it attitude.

Key Words—Vocabulary for Study, Discussion, and Critique

1. Advertising design
2. Archetype
3. Attitude
4. Bad design
5. Charged
6. Constructivism
7. Copy heavy
8. Counterculture
9. Counterpoint
10. Deconstruction
11. Design style
12. Editorial position

13. Experimental
14. *First Things First* manifestos
 (1964, 2000)
15. Formal design
16. Format
17. Futurism
18. Good design
19. Icon
20. Kinetic
21. Layout
22. Loaded
23. Mainstream
24. Overprint
25. Point of view
26. Portfolio
27. Print
28. Public service
29. Publication designer
30. Retro style
31. Russian revolutionary design
32. Screenprint
33. Spread
34. Target audience
35. Theoretical
36. Vernacular design
37. Visual metaphor
38. Visual pun

Letters and Words

Letters, words, and images are the building blocks of *visual communications*. Letters are *symbols,* representing the sound elements of a written and spoken language. Components of an *alphabet,* letters are the individual units used to create words and, of course, words are used to construct sentences and longer, more elaborate texts. In addition to communicating meaning and content, letters have *graphic form.* Through centuries of evolutionary development, letters have attained an exquisite degree of beauty and precision, a balance of form and function. Although letters have specific *anatomical* parts, their form remains open to almost limitless variations.

Letters and words are created by specialists, such as *lettering artists* and *type designers,* or by graphic designers working with *typographic software.* *Typographic designers* modify existing *typefaces* (or create original designs) and orchestrate the arrangement of type in a layout. With the advent of the personal computer, graphic designers, for the first time in history, have the tools of type design, typesetting, and typographic design right at their workstations.

Because words are made from multiple letters, their graphic form is highly complex and visually rich. Designers use letters and words for their visual form as well as their content. Working within the parameters and goals of the design project, the designer makes informed choices with regard to the visual treatment and placement of words. The creative possibilities available when using letters and words are so vast that some designers choose to work only with text. Usually, however, designers use all three building blocks of communication; letters, words, and images. This chapter covers the use of letters and words in graphic design, whereas chapter 6 addresses the use of images.

Letters

As stated earlier, the individual letters of the alphabet are constructed from anatomical parts. The parts are as identifiable as the parts we associate with human anatomy, and the anatomical terminology is similar: letters have arms, shoulders, legs, and ears. Letters may be hand-drawn original artwork,

or they may be generated as a typeface, in a form suitable for mechanical or digital reproduction. Typefaces belong to families, such as Old Style, Transitional, Modern, Slab Serif, Sans Serif, or Decorative Display; each *typeface family* is characterized by its unique anatomical features. Each individual typeface design (such as Gill Sans, or Garamond) exists as a *font,* consisting of uppercase and lowercase characters, numerals, and punctuation marks, in one size. A typeface may also be available in variations of weight or width, and in *Roman* or *Italic* form, each variation entailing a separate font. The typographic design in **figure 5-1** displays several anatomical features. The *formal* Roman letter *W* in the background has a *vertical stress* and stands firmly on its *feet.* Its diagonal strokes are strongly angular, creating an abstract geometric design.

Roman letters, as their name suggests, are based on the formal letter style inscribed on Roman monuments, such as Trajan's Column. The *strokes* defining the shape of the letter end in *serifs,* which provide a horizontal flow, useful when creating lines of text intended to be read horizontally. Serifs may be derived from chisel-marks made by the stonecutter at the start and finish of a stroke. The style of the foreground letter in figure 5-1 is *informal,* consisting of a single, beautifully rounded, organic stroke. The letter's right-hand slant reveals its ancestral roots in hand lettering. Notice how the designer has emphasized the abstract structure of each letterform by focusing on the negative spaces between strokes, the shapes created by overlapping strokes, and the dynamic contrast between formal and informal design.

The two-sided insert designed by Rudy VanderLans for his innovative graphic design publication, *Emigre,* uses overlapping and abstraction in a more complex way **(fig. 5-2).** The text reads "Emotion/Reason" on one side of the sheet, and "Reason/Emotion" on the other side. The words are boldly

Fig. 5-1. Typographic design, formal and informal letters.

Fig. 5-2. Rudy VanderLans, designer, Julie Holcomb, printer, *Emotion/Reason. Emigre 12,* 1989.

overlapped, with one word positioned vertically and the other horizontally. Each word is printed in a different color, the foreground word in red, and the background word in gray. VanderLans gets double duty from his concept; on the *formal design* level, the overprinted words are energetically abstract; on the *content* level, the oppositional definitions of the two words are emphasized by the *layout.* The red, foreground word "Emotion" dominates the design on one side of the sheet, while on the opposite side "Reason" is predominant. Design and content are linked; the reader puzzles over the conceptual conundrum.

The insert is printed by *letterpress* on a paper different from the rest of the publication. In letterpress printing, wood, metal, or polymer plates are inked on their surface and, using tremendous pressure, imprinted directly onto the printing paper. The *stamped* image, deeply impressed into the paper, gives letterpress its distinctive look. Although letterpress was eclipsed long ago by the speed and economy of *offset* printing (and, more recently, direct digital printing), it continues to be used for handprinted limited editions and for occasions where a handmade, more tactile image is desired.

The drawing or rendering of letters is an art form. Letters may be drawn for a particular application, such as a book title, or they may be part of a complete alphabet destined for photomechanical or digital reproduction. During the Renaissance, elaborate capital letters were lavishly decorated with intertwining vines, abstract patterns, and fantastic creatures **(fig. 5-3).** The designs were cut in relief on wood or metal blocks and printed by the letterpress process described above. The design style is derived from the hand-drawn, colored letters used in *illuminated manuscripts* of the Middle Ages.

Fig. 5-3. Ornamental letter, 15th century. *Ready-to-Use Ornamental Initials: 840 Copyright-Free Designs Printed One Side.* Dover Publications, 1994.

In contrast to the labor-intensive (and therefore very rare) hand-lettered manuscript, the letterpress process enabled printers to reproduce a text over and over again, until the blocks were worn out. As was the case in manuscript design, the illuminated capital letter was used to signify the beginning of a new paragraph and to emphasize the relative importance of a section of text. As seen in figure 5-3, letters also included pictorial imagery relevant to the content of the text. Today, designers use *drop caps* or *initial letters* in a similar manner. Decorative letter styles are effective when used to create visual contrast with strictly functional or geometric elements. Letters identified with certain period styles, such as *Art Nouveau,* can be used when a deliberate historical reference is appropriate.

Daniel Pelavin's brilliantly drawn study of a hand-lettered *monogram* for the New York Type Directors Club is an excellent example of how a historical style can be relevant in a contemporary context **(fig. 5-4).** While Pelavin's work reveals his appreciation of design history (in this case, making reference to nineteenth-century ornamental lettering), he is also admired for his highly refined drawing abilities and skillful use of conventional tools and materials. Equally remarkable is his ability to transfer those skills to the computer. More recently Pelavin has refined his visualization techniques to the point where his preliminary studies, or *comps,* have become much less detailed, often no more than a doodle or rough sketch (see fig. 3-3).

The interior face of Pelavin's poster displays the large, fully rendered monogram of figure 5-4 in full color, placed against a background alphabet of turn-of-the-century decorative letters **(fig. 5-5).** The poster/prospectus, designed to announce the annual Type Directors Club competition, rightfully emphasizes the beauty of hand-drawn letters and the importance of impeccable artisanship. The poster fulfills its immediate function as a

Fig. 5-4. Daniel Pelavin, pencil layout. New York Type Directors Club, 1992.

Fig. 5-5. Daniel Pelavin, poster. New York Type Directors Club, 1992.

call-for-entries, while at the same time raising the exhibition's standard of design excellence.

Letters or groups of letters are often used as the basis for *identity marks*, which are graphic *icons* used to establish the visual identity of a company, organization, or event. To establish a memorable image, identity marks are applied consistently over a long period of time. When only the initial letters of a company's name are used, the mark is called a *lettermark*. When the company's entire name is used, it's called a *logotype* (after *logos*, or word). The author used the initial letters of "Film Festival" as the basis of the lettermark he created for the First Annual Border Film Festival **(fig. 5-6).**

As the event title suggests, the festival featured films from both sides of the United States–Mexico border. After reviewing the options, the designer and his client decided to focus on three ideas: the initial letters *FF*, a strip of motion picture film, and the conceptual meaning of "border." The final design is based on the two *Fs*, reversed out of black, positioned face-to-face, and offset vertically. This configuration created a complex form revealing two additional *Fs*, which are black and are back-to-back. With a little imagination, the resulting design takes on multiple meanings, extending the concept beyond just a simple use of initial letters: (1) the letters are divided vertically, creating an implied face-off, as a metaphor for border issues; (2) the strong contrast of black and white and the narrow proportions of the letters make

Fig. 5-6. Louis Ocepek, identity mark, The First Annual Border Film Festival. Fountain Theater, 1995.

reference to the frames of a filmstrip; and (3) the repetition of the four letters creates a geometric Mexican or southwestern design motif.

Identity marks are used in a variety of communication formats (such as business stationery, brochures, advertisements, posters, web sites, etc.), usually at different sizes and in a wide range of media. A black and white version, the easiest and most economical form to print or copy, is usually developed first, keeping in mind that color can be added later if necessary. The Border Film Festival mark was used as the primary image for the festival poster as well as for advertising and public relations **(fig. 5-7).** Throughout the project, the mark was used in a wide array of sizes; for the poster, several large-scale marks were overprinted to imply the transparency of motion picture film, and it was also reproduced at a very small size to create the running-edge border; for newspaper advertising, the mark was used at tabloid size as well as for small-space ads; and, it was used at larger-than-life size in the festival theater.

Even a single letter can be successfully used as the focal point of a layout, particularly if it relates to content and has an engaging graphic form. Since letters are omnipresent in our lives, they almost always attract our attention. The cover design by Jeff Neumann for the entertainment tabloid *Wild Life* features the historical letter style known as black letter or, more accurately, *textura* **(fig. 5-8).** The evolution of textura as the basis for typeface design can be traced to Gothic manuscript lettering. Textura is characteristically

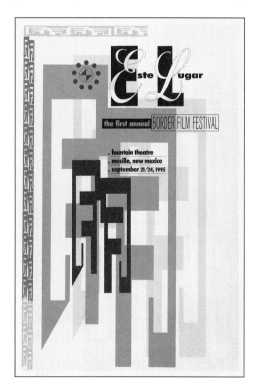

Fig. 5-7. Louis Ocepek, poster, *Este Lugar, The First Annual Border Film Festival.* Fountain Theater, 1995.

Fig. 5-8. Jeff Neumann, cover design, *The Scarlet Letter. Wild Life, Albuquerque Tribune,* 1995.

angular, the form of its thick and thin strokes controlled by the use of a square-tipped pen point. Heavily identified with Germany, textura, as a type form, remained popular until the 1930s.

The subject of Neumann's cover is *The Scarlet Letter,* a contemporary Hollywood version of Nathaniel Hawthorne's novel of 1850. Neumann's unusually minimal layout is surprisingly sophisticated for this type of tabloid: the title of the film and the graphic form are completely integrated (the primary graphic form is the scarlet letter *A* of the title, forcibly worn on the breast of the protagonist as public castigation for adultery). Neumann stripped the cover of all extraneous elements, minimizing the visual effect of the remaining text (such as the titles of the interior articles and their page numbers) by setting it in very small, all-lowercase letters, positioned at the edges of the cover, isolated from the central design. The scarlet letter *A* is placed dramatically against a solid black background, the red glow of its outside edge reinforcing the heated moralistic theme of the film.

Although a successful cover design could be made with just the glowing letter, a layer of content was added to the solution by masking images of the actors inside the letter *A*, adding a human element to the cover. Additionally, the letter's profile against the black ground creates a keyhole through which the reader voyeuristically observes the central characters, enhancing the film's controversial subtext regarding moral judgment and sexual behavior.

Fig. 5-9. James A. Houff, poster, *April in April.*
AIGA Detroit, 1991.

James Houff's poster for an American Institute of Graphic Arts presentation by the designer April Greiman **(fig. 5-9)** is also constructed around the letter *A*. In this case, Houff's analysis of the assignment resulted in a multilevel layout incorporating intelligent word play, exquisite formal design, and first-class production values. Greiman was speaking in April, and her first name is April, so Houff chose to use an *A* as the predominant image. By masking a photograph of rippled water inside the contour of the letter, Houff pays tribute to Greiman's signature style, which she calls *hybrid design.*

Enhancing content are witty copy lines such as "April in April" and "They will come" (which can also be read as "Will they come," a sly reference to the difficult task of getting AIGA members to attend such presentations). Houff's poster is layered conceptually as well as visually: everything in the poster has meaning as well as form; water imagery figures heavily, referring to April showers, as well as Michigan's many lakes and rivers; and a flower is used to symbolize both spring and women in design. On the visual level, Houff displays a masterful ability to create the illusion of dimensional space on a two-dimensional surface. The poster's elements are arranged in a carefully ordered *hierarchy,* starting with the large central letter and continuing down through the smaller, more understated images. The full content of the poster reveals itself gradually, richly rewarding the viewer's careful reading.

Words

Many of the principles pertaining to the design and use of letters apply to words as well. However, words, being composed of multiple letters, are much more visually complex. The designer looks at this complexity as a virtue; a kind of visual complexity that can be used to advantage, and is often interesting enough to carry an entire design. Lee Willet, in his poster *Holiday Ball* designed for Pratt Institute, makes good use of the complex form of a single word **(fig. 5-10).**

As in the two previous posters, this design is also centered on the letter *A*. In this case, the letter is found in the word *Ball* (of "Holiday Ball"). The large, slab-serif letter anchors the poster, its bold, thick serifs providing the solid footing upon which the other elements depend. The diagonal strokes of the letter are wide enough to accommodate a masked photograph of the Brooklyn Botanic Garden, the location of the Ball. Willet also discovered that the *counter form* of the *A* had a shape similar to that of a Christmas tree.

Fig. 5-10. Lee Willett, poster, *Holiday Ball.*
Pratt Institute, 1998.

With the second color, he added a stylized star and a few stylized ornaments to complete the reference. Willet also exploits *typographic variation* to express a lively holiday mood; the word *Holiday* is broken into two parts, each part arranged on a contrasting diagonal. Although the word is set in all caps, each segment is set in a different size, and one part is positive and the other reversed. The word *Ball* is also playfully disrupted; each letter is set in a different typeface, and placed at a contrasting angle to the central *A*. Willet skillfully uses Old Style, Sans Serif, Slab Serif, and Decorative Display typefaces, all in the same poster. Although Willet had only two colors available, he achieved visual and conceptual richness through his inventive use of typographic design and production.

The expressiveness of hand lettering is carried to the limit in a poster for the Zozobra festival in Santa Fe, New Mexico **(fig. 5-11).** During the Zozobra festival, traditionally held in September of each year, a 50-foot-tall effigy of this gruesome character, symbolizing the trials and tribulations of the previous year, is paraded through the city. Following the celebratory procession, Zozobra is condemned and burned; as the flames reach high into the sky, the ills and troubles of the expiring year symbolically dissipate. In contrast to the daily barrage of computer-generated, slickly printed design, this poster is refreshingly original and energetic. Drawn in the same style and character as

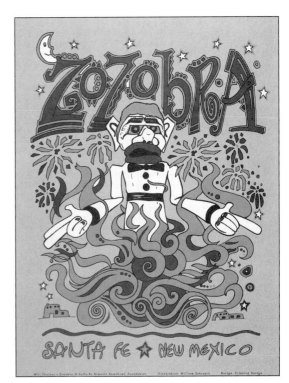

Fig. 5-11. Cisneros Design, poster(s), *Will Schuster's Zozobra,* William Rotsaert, illustrator, 2000.

the illustration of Zozobra, the designer's wildly unique, hand-drawn letterforms effectively express the festival's exuberant mood. Word and image are beautifully integrated in style and content, evoking the visual excitement of this uniquely New Mexican celebration.

For the designer, the repetitious pattern of words on the page is seen as *texture.* As pointed out by Philip Meggs in his book, *A History of Graphic Design,* the words *text* and *texture* are related in meaning. The Latin origin of the word "text" is *texere,* to construct, and the origin of the word "texture" is *textura,* that which is woven. An early example of typographic texture can be seen in Johannes Gutenberg's greatest work, the forty-two-line Gutenberg Bible of 1450–1455 **(fig. 5-12).** Gutenberg is credited as the inventor of *movable type,* the typesetting process by which a text could be reproduced in large number, for wide distribution. This process revolutionized printing and, for the first time, democratized the dissemination of knowledge. The Gutenberg Bible is magnificent in the density and evenness of its typesetting, created with impeccable *letter, word, and line spacing.* The even texture of the type columns is wonderfully relieved by the insertion of exquisitely painted initial letters and borders.

Rudy VanderLans treats words as a flat plane of texture in his layout of an *Emigre* interview with designer/printer/musician Bruce Licher **(fig. 5-13).**

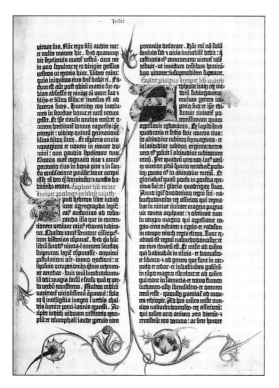

Fig. 5-12. Johann Gutenberg and Johann Fust. *Biblia Latina (Latin Bible)* [c. 1455]. v. I, f.266. PML 12. The Pierpont Morgan Library / Art Resource, NY.

Fig. 5-13. Rudy VanderLans, page layout. *Emigre 16,* 1990.

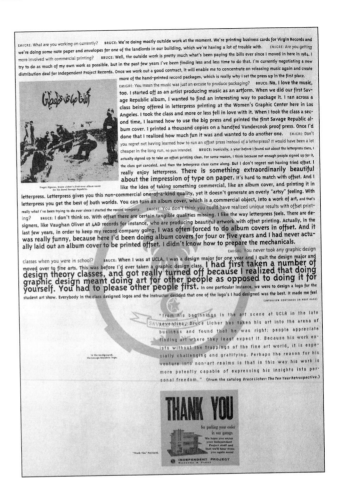

Two fonts are used, *Emigre's* Triplex (Sans) Bold and Triplex (Sans) Light. The two fonts create different values of gray on the page (paradoxically called "color" in typographic jargon), visually distinguishing the two voices of the interviewer and interviewee. The dense, even setting of the text, the monochromatic photographs, and the buff paper stock produce a documentary tone of immediacy. As the reader's eye moves down through the text, VanderLans gradually increases the *point size* of the bold type, creating the subtle implication of foreground to background space as well as volume. The impeccable line spacing, or *leading,* the *justified* columns, and the evenly weighted fonts all contribute to a beautifully orchestrated page.

Why Not Associates' masterfully articulated, extremely complex poster for the band Living in a Box requires commitment on the part of the reader to decode its message **(fig. 5-14).** Interpenetrating layers of text, extreme typographic variation, and digital manipulation address issues of *deconstruction, ambiguity, legibility,* and *abstraction.* The phrases "living in a

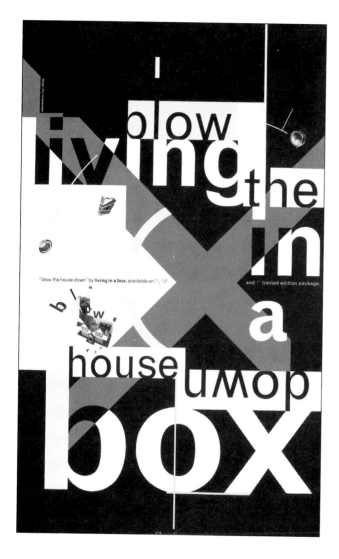

Fig. 5-14. Why Not Associates, poster,
Living in a Box. Chrysalis Records, 1989.

box" and "blow the house down" project themselves concurrently, moving from left to right and top to bottom, even appearing to move from foreground to background, in an illusionary third dimension. Words and letters intersect one another, cut by flat planes of red and black. As a suburban house is "blown down," the letters of the word *blown* fly around in the negative space. An implied grid and a large red *X,* almost centered on the sheet, provide some stability. The complex, agitated esthetic seems appropriate for an album of alternative music by a group called Living in a Box; perhaps the poster represents a metaphorical escape from the "box" of conformity. Why Not Associates' confident handling of design fundamentals and outstanding technical prowess support the firm's elevated level of design experimentation.

Key Words—Vocabulary for Study, Discussion, and Critique

1. Abstraction
2. Alphabet
3. Ambiguity
4. Anatomy of letters
5. Art Nouveau
6. Comp
7. Counter form
8. Deconstruction
9. Decorative display
10. Digital
11. Drop cap
12. Font
13. Formal letter style
14. Graphic form
15. Gutenberg
16. Hand lettering
17. Hierarchy
18. Hybrid design
19. Illuminated manuscript
20. Icon
21. Identity mark
22. Informal letter style
23. Initial letter
24. Italic
25. Justified
26. Layout
27. Leading
28. Legibility
29. Lettermark
30. Letter spacing
31. Lettering artist
32. Letterpress
33. Line spacing
34. Logotype
35. Monogram
36. Movable type
37. Negative space
38. Offset
39. Old Style
40. Point size
41. Roman
42. Serif
43. Stroke
44. Style
45. Symbol
46. Terminal
47. Textura
48. Texture
49. Type designer
50. Typeface
51. Typeface family
52. Typographic software
53. Typographic variation
54. Visual communications
55. Word spacing

6 Images

Images are essential elements of graphic design; when used in conjunction with words, they enhance visual communication. Designers use a variety of pictorial representations, including *photographs, illustrations, pictographs,* and *symbols,* to inform, identify, persuade, and otherwise engage the reader's attention. Images can be manipulated to emphasize reality, distort reality, or even create the obviously unreal. Designers often transform or edit pictures (especially photographs) to change the expressive or conceptual content. The designer chooses the pictorial representation that best fulfills the creative and practical needs of the assignment.

Designers can create their own images, or they can purchase or commission them from other artists or design specialists. Designers with the artistic and technical skill to produce their own imagery have more control of the design process and its outcome.

All pictorial representations, even those that appear to be "realistic," reflect the artist's point of view. For example, *photojournalists* have an "angle" on the story they're reporting; *advertising photographers* address the needs of the client and the *marketplace; editorial illustrators* express the editorial position of the powers that be. Different kinds of pictures communicate differently, from the exactness of *realism,* to varying degrees of *stylization,* to *symbolism* and *abstraction.* Each of these modes of representation has its own usefulness and esthetic value; graphic designers are expert at choosing the right image, typographic treatment, and layout for each project. (Incidentally, there are *copyright* issues to be considered when using images found in books, magazines, and newspapers, or on the Internet.) Ultimately, images of all kinds are dynamically arranged with text and other graphic elements to complete the project.

Realism

The photographic image is the pictorial mode most closely associated with realism, and it remains a powerfully convincing medium. The photograph used in a recruitment booklet for U S West (now Qwest Communications),

Fig. 6-1. Vaughn Wedeen Creative,
publication design. Interior page, *Where Do
We Go from Here? Job Opportunities at U S
West.* U S West Communications, 1998.

a communications company, expresses the U S West lifestyle **(fig. 6-1).** Although not heavily manipulated, the photograph was art directed to project a very specific reality. The text accompanying the photo addresses the prospective employee's desire for a quality lifestyle, one that can be "celebrated," rather than "tolerated."

At the time, U S West's operational territory encompassed fourteen of the western states, including some of the most desirable locations in North America. To portray the healthy western lifestyle, the photographer used a strong, wholesome model, picturing her in a ruggedly beautiful landscape. To project an image of social and financial well-being, her clothing is first-class, and, in this idealistic world, dogs run free. The photograph has a warm, friendly tone, suggesting a pleasant, natural location—an environment we would all like to be in. The photographer framed the picture from an interesting *viewpoint:* the exaggerated *foreshortening* of the figure, and the graphic *silhouettes* of the dogs improve the artistic quality of the image. A modern roman typeface is used for the *overprinted* text, beautifully letterspaced and precisely positioned. This is quality work, meant to reflect the quality of U S West as a company, and the quality of life enjoyed by its employees. The picture, viewed as one element from the larger context of the entire booklet, successfully *documents* a time and place, while intimating an attitude and lifestyle.

Photography can also be used in a less literal, more expressive manner. At the heart of a cover designed by Jeff Neumann for the *Seattle Times* entertainment *tabloid Ticket,* is a realistic photograph of a painted black man peering out at the reader from behind his outspread fingers **(fig. 6-2).** The subject of the cover is WOMAD (World of Music, Art and Dance), Seattle's annual festival of World Music. The photograph is large, almost life-size, *cropped* by the edges of the cover. Mysteriously, the man's hand is positioned with the palm facing out, the powerful graphic form suggesting a ritualistic, defensive, or even protective posture. The text ("The World According to WOMAD") is masked inside the contour of the hand, uniting word and image while promising an exotic, archetypal kind of music, most likely from other places. The eye peering out from behind the hand attracts attention by making eye contact with the reader. Neumann skillfully orchestrated the layout so that most of the secondary text material is along the outer edges of the cover, a *framing* device that allows the photograph to dominate the space without distraction.

Because we are culturally habituated to believe that conventional photographic images are realistic, skillfully manipulated photographs can be especially effective. *Photomontage,* the technique of juxtaposing like and unlike images to create a new reality, was developed by *Dada* artists in Zurich and Berlin in 1918, as a way to express their nihilistic philosophy and disgust

Fig. 6-2. Jeff Neumann, cover design, *WOMAD. Ticket, The Seattle Times,* 1999.

with the current state of politics. Photomontage is an effective medium for the transmission of *narratives* using photographic imagery to create imaginary situations. In the beginning, photomontage was made by hand; using *cut and paste* techniques, considerably augmented by retouching. As a result the work was strongly personal and looked handmade. Today, virtually seamless photomontage can be created using digital techniques, enabling the designer to create remarkably convincing representations.

James Houff used photomontage in his poster for a broadcast design seminar **(fig. 6-3).** The poster exhibits Houff's interest in *layering,* visual *ambiguity,* and symbolism. Photomontage also permits him to remain relevant to his audience of broadcast design professionals. The images of hand, eye, alphabet, lens, *halftone* dots, texture, RGB (red, green, blue) icons, sound wave and light rays all allude to aspects of broadcast design. Houff cut and pasted these images together to create a masterful composition, a visual *icon* comprised of interrelated forms that invite interpretation. There seems at first to be a high level of abstraction, but as the reader is drawn further into the poster, an elegant logic is revealed. Surprisingly, this poster has an absolute minimum of text, which shows itself only upon careful study. Such a complex concept requires a superior comprehension of formal design issues, *communication theory,* and graphic production.

Fig. 6-3. James A. Houff, poster. Broadcast Designers Association and Broadcast Promotion and Marketing Executives Seminar, 1989.

Like photography, certain styles of illustration are suitable for the expression of realistic imagery. Realism is dependent on the ability of the artist to render objects in *continuous tone,* or to at least create the illusion of continuous tone. Because conventional graphic design is destined for print, a printing process that can reproduce the illusion of value, or tone, is critical. Prior to the fine-art medium of *lithography,* which is capable of printing intermediate tones of gray and, later, the commercial halftone screen, which converts rendered images into dots that create the illusion of tone, realistic images destined for reproduction had to be *engraved* or *etched.* The fine lines describing the image were inscribed into the surface of a wood or metal plate, which was then inked in relief. The inked plate was placed on the bed of the printing press, a sheet of dampened printing paper was placed on top of the inked plate, and, under tremendous pressure, the inked image was transferred from plate to paper.

As demonstrated in an illustrated bookplate from a ninteenth-century French volume, graphic artists achieved incredible detail, and a convincingly realistic *value* range, using only line **(fig. 6-4).** Looking closely, the reader can see that the image is made entirely of meticulously engraved parallel and *crosshatched* lines; remarkably, there are no true gray values, only the illusion of gray. In graphic production terminology, this kind of artwork is called *line*

Fig. 6-4. N. Rémond, engraving, *Couronne de Lumière,* Paris, 1862. Private collection.

copy. As with photography, the personality of the artist is present even in such a realistic rendering. The inherent limitations of line art require decisions regarding how much detail and which detail should be included. Despite the apparently realistic result, there is considerable *visual editing* involved during the creative process.

Contemporary designers often use engravings for their sharp, graphic line quality and period look. Because the actual engraving process is such a demanding and specialized skill, designers who wish to incorporate an engraving in their work almost always rely on readily available reproductions, or *stock images*. *Digital imaging programs* and *digital screen filters* can also be used to convert a continuous tone image into a facsimile engraving. Virtually any commercial printing or copying process, such as offset lithography, letterpress, screenprinting, or direct digital-to-plate, can easily reproduce line engravings.

Bruce Licher, proprietor of Independent Project Press in Sedona, Arizona, used copyright-free engravings on his record jacket for the band Live **(fig. 6-5).** Independent Project Press specializes in letterpress printing, graphic design, and the production and distribution of records and CDs. The engravings, together with accompanying text, are deeply imprinted on the jacket's thick card stock. The design style and the look of the print process signal the unique quality of the band's music. On the back of the jacket, an edition number notates the limited run of production, making each album rare and collectible.

Fig. 6-5. Bruce Licher, Independent Project Press, album jacket, *Live.* Action Front Records, 1999.

Fig. 6-6. Vaughn Wedeen Creative, poster, *Zoo Boo Three*. Rio Grande Zoo, 1991.

Vaughn Wedeen Creative used line art as the key image of their *Zoo Boo* poster for the Rio Grande Zoo **(fig. 6-6).** When line art is drastically enlarged, the textured edges of the artwork are vastly exaggerated; the image becomes outrageously graphic. Designers employ this extremely graphic look for its handsome attention-grabbing promise. Rick Vaughn and Steve Wedeen, widely celebrated for their smart and witty approach to graphic design problem solving, costumed their tiger in a fashionably stylish Halloween mask. The mask, with its fluorescent color and contemporary style, introduces an element of festive humor.

A revolution in print technology came about with the development of the lithographic printing process. Lithography enabled artists to draw and print virtually continuous tone images, without resorting to line copy techniques. Invented by German Aloys Senefelder in 1798, *lithography* is a process in which the artist draws on a fine-grained slab of limestone using greasy crayons, pencils, and brushes. The drawing is created in much the same manner as when working on paper; line, as well as continuous tone shading and tonal washes, can be employed. The process is dependent on the antipathy of water and oil; after the drawing is complete, the stone is dampened with water and then "inked up" with an oil-based printing ink. The ink is attracted to the areas where the artist drew with the oily medium, and repelled from the wetted, nonprinting areas of the stone. When inking is complete, dampened printing paper is laid on the stone, and the stone and paper are run through a press under tremendous pressure, transferring the inked image

from stone to paper. Lithographic prints require a separate stone for each color of the final image; each printed sheet passes through the press several times, once for each color to be printed, each successive color precisely *registered* to the previous ones. Stone lithography is the antecedent of the present day commercial printing process, *offset lithography*.

To render pictorial form in a realistic manner, color and shading are used to enhance *volume,* while line is used to define edges and boundaries. Illustrators or designers who create this kind of work usually have a strong background in drawing and painting. Realism, however, is used not only to portray the world as we see it, but it can also be used to make an imaginary world more credible.

In his poster for a summer program in the arts that takes place on the Oregon coast, the author's rendering technique contributes to the illustration's *surreal* atmosphere **(fig. 6-7).** To achieve the appropriate level of realism, a tight, preliminary drawing was made from an actual basket of shells; the drawing was transferred to board and the finished artwork painted in *gouache* and *acrylic*. Importantly, the artist's viewpoint of the shells is from directly above, emphasizing the basket's almost perfectly round shape. By making the basket so strongly geometric, the designer gave the poster a targetlike focus, almost magnetically attracting the viewer's attention. The contrast between the highly detailed, idealized rendering of the shells and the precise

Fig. 6-7. Louis Ocepek, poster, *Summer by the Sea.* Summer Program in the Arts, Portland State University, 1978.

geometry of the basket contributes to the subtle hyperrealism of the image. To heighten this feeling even more, the basket of shells hovers in front of a soft and distant seascape that includes an amorphous, whalelike cloud, hopefully inspiring dreamlike memories of a pleasant day at the beach.

Stylization

Heightening the graphic quality of an image, often at the expense of realism, is called stylization. The illustrator can employ visual editing to stylize an image, simply eliminating extraneous detail, or the image can be stylized by choosing tools that encourage simplification. The woodcut technique, for example, results in solid strokes and shapes (negating the use of intermediate tone, except for the roughly tonal illusion created by stippling or crosshatching), resulting in a bold and powerful image. Although related in technique and printing process to the wood engraving, woodcuts are made using a softer woodblock and broad cutting tools, resulting in a graphic image with dramatic shadows and brilliant highlights. This kind of image is easily reproduced because of its high contrast, coarsely rendered detail, and limited tonal range.

A narrative illustration from the Almanach of the Shepherds demonstrates the typically strong lines and visual contrast of a fifteenth-century woodcut; the edges of objects and figures are delineated by heavily weighted outlines, while shadows are rendered in parallel lines of a lighter weight **(fig. 6-8).** Despite its simplicity of form, the sparkling black and white woodcut communicates its content with vigorous emotional strength.

The stylizations of David Lance Goines are uniquely identifiable, his work easily differentiated by his rare combination of drawing skills and his graphic sensitivity to *line, shape,* and *pattern*. Early in his career, Goines gained invaluable experience as the owner of a print shop, where he worked as designer, lettering artist, and printer. Producing finely printed, limited-edition posters, as well as more ordinary job-work, Goines was involved in all aspects of design and *production,* enabling him to refine every detail of his artwork. As a political activist, Goines seems to have always taken a personal interest in the important issues of his time, as evidenced by his poster for AIDS prevention **(fig. 6-9).** The key image of the poster is essentially a black and white woodcut, with spots of color added for dramatic effect, and to highlight details. Black lines and white interspaces are almost equally distributed, which to some degree camouflages the central image of snake and apple. The elegant, winding line (reminiscent of Art Nouveau), together with the lush setting and sophisticated typographic treatment, captures the reader's attention. As the visually complex design is deciphered, the narrative content is revealed; in a powerful, yet palatable style, the Garden of Eden theme is reworked for a contemporary audience.

Fig. 6-8. Le Rouge, P., woodcut, *Interior scene with couple at table.* From the *Almanach of the Shepherds,* 1491. Giraudon / Art Resource, NY.

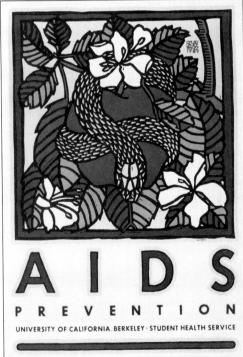

Fig. 6-9. Goines, David Lance, poster, *AIDS Prevention.* Photo-offset lithograph on paper, 1985. Smithsonian American Art Museum, Washington, DC / Art Resource, NY.

McRay Magleby is a designer known for his intelligent and witty ability to relate words and images. His graphic solutions grow out of his analysis of the communication problem and his work is always fresh and relevant. Asked to design a rather mundane registration poster for Brigham Young University, Magleby surprisingly chose the exquisitely ornamental style of the ancient Greeks **(fig. 6-10).** His stylized design is remarkably appropriate for the brilliantly clever text, which exploits the Medusa myth to tell a cautionary tale about the dangers of late registration; the beauty and refinement of the design solution ultimately transcends the rather ordinary function of the poster. Magleby worked closely with a *copywriter* and a *screenprinter* to produce his award-winning posters for BYU. As with the posters of David Lance Goines (fig. 6-9); working directly with an in-house printer ensured quality control, and allowed the team to experiment with color variations and special effects. Using a reversed-out line, the graphic figures in this series of posters are beautifully delineated, the shapes filled with subtle gradations of color. Magleby's design is a harmonious interplay of carefully articulated *positive* and *negative* shapes; the elegantly controlled *split-fountain gradients* are a testimony to his superb sensitivity to color and expert control of print production. As a result, an ordinary assignment becomes a memorable work of art.

Ann Marra's poster, *The Writes of Spring,* designed for a retail store specializing in fine personal stationery, pushes the limits of graphic stylization

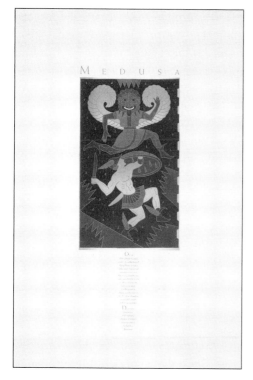

Fig. 6-10. McRay Magleby, poster, *Medusa.*
Brigham Young University, 1987.

Fig. 6-11. Ann Marra Design, poster, *The Writes of Spring*. The Paper Parlour Limited, 1980.

(fig. 6-11). Her *reductive* design dramatically emphasizes primary shapes, enhanced by a strong use of pattern and color. Marra's sophisticated use of space, natural form, and compositional movement reflects her interest in (and formal study of) Japanese design and printmaking; her artwork is gracefully animated, the shapes elegantly arched and organically alive. Delightfully decorative butterflies emerge from in and around a flatly patterned envelope, perhaps symbolizing messages en route to their recipients. A butterfly is cropped into the upper right corner, activating the layout space while implying action outside the *picture plane*. Rhythmically linear calligraphic lettering is used for the headline, its text well integrated with the linear curves of the illustration. Marra's broad use of contrasting color and decorative design is enhanced by the high quality of the printing; rich layers of color lie beautifully on the paper. The combination of elegant design and excellent production values projects an image of "writing as a sensual experience."

Pictographs and Symbols

Pictographs and symbols are extremely simplified images that not only communicate ideas pictorially, but also have the potential to transcend language differences or even illiteracy. Pictographs are usually more readable than symbols, which have a higher degree of abstraction. Enough visual detail remains in a

Fig. 6-12. Pictographs. *Pictorial Archive of Printer's Ornaments from the Renaissance to the Twentieth Century.* Dover Publications, 1980.

pictograph to ensure direct comprehension. The ornaments shown in an early-twentieth-century printer's specimen book demonstrate two stages of visual editing **(fig. 6-12).** The telephone on the left shows a low level of abstraction and contains more detailed information; most people would say it's more "realistic." The image on the right has been more highly edited and is likely to be described as more "abstract" or symbolic. Both images can easily be read as telephones, but one shows a specific telephone and the other shows the idea of a telephone. The left-hand image conveys specific information about the exact *kind* of telephone. The right-hand image sacrifices specifics for boldness and quick recognition; broad outlines and only the most essential details are included. The designer decides which level of abstraction is appropriate for the job at hand. Pictographs are intended to be memorable and easily reproducible, and can be used as identity marks or as part of a universal *signage system,* such as those found at international trade fairs, airports, and expositions.

The Mescalero, New Mexico, National Fish Hatchery, established to restock tribal waters and restore endangered trout species to their native habitats, required a comprehensive *information design* program for its Visitors Center. Used primarily to orient visitors to the workings of the hatchery, the graphics are of particular interest to visiting school groups. Following their orientation, groups tour the hatchery itself, observing firsthand the workings detailed in the Visitors Center. Among the categories of information conveyed is a section picturing the routine tasks hatchery workers perform daily, such as hand-feeding developing fish with dry food pellets **(fig. 6-13).** Other images show technical equipment and tools typically used at the hatchery. The author chose the pictograph form for its dramatic readability, designing an entire system of related images in a consistent visual style. Working from actual objects and photographs, he simplified the pictures, retaining only the

Fig. 6-13. Louis Ocepek, pictograph. Visitors Center, Mescalero National Fish Hatchery, 1986–1992.

Fig. 6-14. Louis Ocepek, pictograph. Visitors Center, Mescalero National Fish Hatchery, 1986–1992.

most important aspects and labeling the illustrations with a clear, easy-to-read typeface **(fig. 6-14).**

When pictographs of a less detailed, more *universal* form are to be used, geometric construction may be a helpful starting point. The sun, for example, is essentially round, emitting heat and light. The starting point for a picture of the sun, therefore, is a circle, or sphere, with a center point from

which light and heat will radiate. After establishing that basic structure, hundreds of variations can be derived **(fig. 6-15).** The snowflake is another generic form that has a geometric structure and infinite variations. When creating alternate solutions, reversing the image is one of the first things a designer tries. Depending on the complexity of the form, even this simple alternative can be interesting **(fig. 6-16).** After making hand-drawn studies, or *thumbnails,* the computer is a tremendously valuable tool for making the many variations designers produce before settling on a particular direction or design solution. At a certain point, some of the more successful studies are *presented* to the client for discussion and approval.

Symbols are used to illustrate not only physical objects, but abstract ideas as well. Daniel Castelao of Signi Design, a company specializing in *corporate identity programs,* created a *combination mark* for an upscale real

Fig. 6-15. Clarence P. Hornung,
pictographs, *The Solar Variant. Handbook of Designs and Devices,* Dover Publications, 1946.

Fig. 6-16. Clarence P. Hornung,
pictographs, *The Snow Crystal. Handbook of Designs and Devices,* Dover Publications, 1946.

Fig. 6-17. Daniel Castelao, Signi Design, symbol. Las Misiónes, 1999.

Fig. 6-18. Daniel Castelao, Signi Design, combination identity mark. Las Misiónes, 1999.

estate development in Mexico City. He combined an abstract symbol **(fig. 6-17)** with a *logotype* or *word design* that spells out the full name of the development **(fig. 6-18).**

Abstract symbols, when used alone, require multiple exposures over a long period of time to attain recognition and acceptance. With a combination mark, however, the text reinforces the meaning of the pictorial symbol, ensuring almost immediate communication. A combination mark, having two components, is more visually complex than either a symbol or a logotype used alone. It has more presence on the page or screen, offers more options

for the addition of value, color, or texture, and can be arranged in various configurations. The combination mark is a useful graphic device; literally and figuratively linking word and image.

For the symbolic portion of the Las Misiónes mark, Castelao created an elegant form that is both an architectural detail and an abstracted letter *M* (the initial letter of the development's name). When the symbol is joined with the beautifully crafted logo, an appropriate image of quality and privilege is communicated. To ensure that the client and third-party service providers use the mark properly, designers often create a *usage* or *application manual* that includes the finished mark, along with examples of how the mark is to appear in every conceivable application.

Key Words—Vocabulary for Study, Discussion, and Critique

1. Abstraction
2. Acrylic
3. Advertising photographer
4. Ambiguity
5. Combination mark
6. Communication theory
7. Continuous tone
8. Copyright
9. Copywriter
10. Corporate identity program
11. Crop
12. Crosshatching
13. Cut and paste
14. Dada
15. Digital imaging program
16. Digital screen filter
17. Document
18. Editorial illustrator
19. Engraving
20. Etching
21. Exhibition design
22. Foreshorten
23. Frame
24. Gouache
25. Graphic production
26. Halftone
27. Icon
28. Illustration
29. Information design
30. Layering
31. Letterpress
32. Limited edition
33. Line
34. Line copy
35. Lithography
36. Logotype
37. Marketplace
38. Narrative
39. Negative shape
40. Offset lithography
41. Overprint
42. Pattern
43. Photograph
44. Photojournalist
45. Photomontage
46. Pictograph
47. Picture plane
48. Positive shape
49. Presentation
50. Production
51. Realism
52. Reductive
53. Register
54. RGB
55. Screenprinter
56. Shape
57. Signage system
58. Silhouette

59. Split-fountain gradient
60. Stock images
61. Stylization
62. Surreal
63. Symbol
64. Symbolism
65. Tabloid
66. Thumbnail
67. Universal
68. Usage manual
69. Value
70. Viewpoint
71. Visual editing
72. Volume

7 Integration of Word and Image

Although graphic designers often use words alone, communication is enriched by the integration of words and images. The ability to *analyze* content, discover *meaning*, and transmit ideas is essential in graphic design. Content is derived from textual and visual material stipulated by the client, and/or gleaned from *research*. While keeping the core requirements of the project in sight, the designer sifts through the content, searching for connections between words and images that will provide fertile ground for visual/verbal exploration. During the research and analysis process, the designer is guided by both intellect and intuition. Leeway is allowed for the fortuitous and unpredictable relationships that often occur.

Words and images have visual form as well as content. The balance between the two is determined by the designer. Katherine McCoy, in *Design Quarterly* 148, 1990, postulates that words are perceived as images and images can be read as words. A contrasting view was offered by typographer Beatrice Warde in her 1932 address, *Printing Should Be Invisible,* in which she proposed that content is paramount and should be revealed through "invisible," unmannered typesetting and printing. In any event, the effectiveness of words and images is maximized by their placement, style, medium, and size. Creative *juxtaposition,* as well as techniques of visual rhetoric, can be used to generate *synergy,* a scenario in which the combined meaning of words and images transcends their individual meaning. In both *print* and *electronic formats,* the *layout* is viewed not only as a flat, two-dimensional plane, but also as an infinitely deep, three-dimensional space. With this in mind, elements can be juxtaposed from side-to-side, edge-to-edge, and foreground to background; there are limitless possibilities for the integration of words and images, each of which affects the reader's comprehension of content.

In their invitation to the groundbreaking ceremony of a Jewish Community Campus, Vaughn Wedeen Creative fuses word and image, literally and figuratively **(fig. 7-1).** Using rhetorical *humor,* the designers position a phrase normally associated with especially intense personal experiences

Fig. 7-1. Vaughn Wedeen Creative, announcement, *The Earth Will Move.* Jewish Community Campus of Albuquerque, 1999.

("THE EARTH WILL MOVE") over a bright yellow toy shovel. The use of visual form and text is extremely direct; the reader instantly associates the words *earth* and *move* with the shovel. The bold red text, set in widely letterspaced sans serif caps, has the verbal intonation of a biblical proclamation. The combined text and image has a double meaning; at the groundbreaking, the earth will figuratively move, in recognition of the historical significance of the event, and earth will literally move as the first shovelful of dirt is symbolically excavated. The effectiveness of the message is enhanced by the smart application of visual rhetoric, and the clarity of visual form.

In the late eighteenth and early nineteenth century, the Industrial Revolution fueled the explosive growth of manufacturing, thereby triggering a need for *advertising* and *publicity.* Inventions and innovations in the *graphic arts* made it possible to reproduce complex layouts combining elaborate typefaces, lettering, and illustration. The *pantograph* made it possible to produce (and accurately duplicate) new wood-type designs directly from drawings. Experiments in *light-sensitive* platemaking expanded the imaging possibilities of letterpress printing. Multicolor printing was enhanced with the invention of *chromolithography.*

Concurrent innovations in photography, papermaking, ink chemistry, and high-speed printing presses were critical to the expansion of the printing industry and, indirectly, *commercial art.* The cover of a farm machinery

Fig. 7-2. Catalog cover, *Twenty Seventh Annual Catalogue of Harvesting Machinery,* D. M. Osborne and Company, 1883. Amador Family Papers, Ms 4ATC, Rio Grande Historical Collections, New Mexico State University Library.

catalog of 1883, a typical example of period commercial art, is designed in the exquisitely decorative Victorian style popular at the time **(fig. 7-2).** To contemporary eyes, the design is surprisingly artistic considering the mundane nature of the product. However, then as now, the farmer would be very concerned about the artisanship and design of such expensive equipment. The design choices regarding letter style and illustration technique create an image of sturdy, artfully crafted machinery. The heavy-duty, dimensional lettering used for the name of the catalog and the manufacturer is superimposed on a silk banner suspended with ribbons from a traditional rake and pitchfork, linking the old with the new. The script employed for the harvest year of the catalog lends a gentile touch that blends nicely with the fine-line backdrop illustration of harvested sheaves of grain. Luxurious *negative space* frames the design, focusing attention on the densely interwoven words and images. The composite design heralds the product catalog of 1883 in an extravagantly theatrical fashion.

Sol Mednick symbolically "locks" words into the pictorial image of his public service advertisement for the Container Corporation of America (now known as the Smurfit-Stone Container Corporation) **(fig. 7-3).** Each entry in CCA's three-decade-long campaign, Great Ideas of Western Man, features an artist's interpretation of a significant philosophical concept. In Mednick's design, the reader is looking straight down on a graphic representation of

Fig. 7-3. Sol Mednick, institutional advertisement, *Benjamin Franklin on Freedom and Security.* Great Ideas of Western Man series, Container Corporation of America, 1953–1954 series.

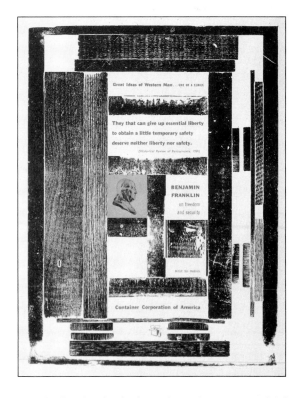

a *chase,* the heavy frame used to hold the *locked-up* foundry-type, relief plates, and *furniture* used in *letterpress* printing. Just as in real letterpress, Benjamin Franklin's quotation about freedom and security ("They that can give up essential liberty to obtain a little temporary safety deserve neither liberty nor safety") is locked up in the chase, tightly secured by the surrounding furniture.

Rather than use a photograph of a lock-up, the relief surfaces of the furniture and locking *quoins* were inked up and printed, creating a handsomely textured, *high-contrast* black and white image. Mednick exercised "artistic license" with the image; because their surfaces are deliberately lower than the relief surfaces of type and plate material, lock-up furniture and quoins aren't normally printable; Franklin's portrait bust, as well as the text, are *right reading,* instead of being the wrong way around, as they would be if the reader was looking at a real lock-up. The visual strength of the ad is created by the innovative, semiabstract representation of the printing process. The conceptual strength lies in the association made between Benjamin Franklin (who was at one time a printer), letterpress printing (the means by which books and newspapers were printed during the Colonial period), and the revolutionary spirit of pamphleteering (the practice of writing and distributing political and philosophical pamphlets). The tightly integrated words and images generate pictorial *and* conceptual power.

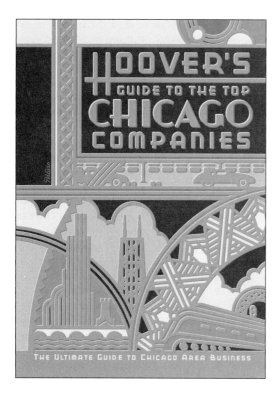

Fig. 7-4. Daniel Pelavin, cover, *Hoover's Guide to the Top Chicago Companies*, 1996.

Daniel Pelavin's cover design for *Hoover's Guide to the Top Chicago Companies* demonstrates how a consistent design style can be used to maintain a tight relationship between words and pictures **(fig. 7-4).** Pelavin understands the visual characteristics of his particular style, which is a personal interpretation of *Art Deco* (named for the Exposition Internationale des Arts Décoratifs et Industriels Modernes, held in Paris in 1925). The pictorial elements, the *decorative borders*, and the text are each delineated using a beautifully *drafted,* evenly weighted line. Pelavin used the computer to apply an *embossing* effect to all the lines and shapes, together with an orchestrated *color palette* appropriate to the Art Deco style. Each element in the design is relevant to Chicago; for example, the decorative border framing the title is fashioned from El Train cars, automobiles, and architectural supports. Rather than simply using existing type for the title text, Pelavin devised a personal lettering style analogous to that of the illustration, skillfully assimilating it into the overall image; the cover design is read first as an integrated whole, and secondly as separate words and images.

Text and image are typically juxtaposed in a side-by-side relationship on the surface of the *picture plane* or overlapped, with each element existing on a separate layer parallel to the picture plane. In either case, text and image remain essentially separate. However, words can also exist *in* images (fig. 7-3), and images can exist *in* words. When images are placed inside letters or

words, the reader is obligated to read the text and the image simultaneously; the eye fluctuates back and forth, reading the image and reading the words.

The Popejoy Hall Ovation Series showcases a wide variety of dance, theatrical, and musical events **(fig. 7-5).** For the cover design of the Ovation Series program, Vaughn Wedeen Creative first designed a *logotype* based, of course, on the word *Ovation.* Fashioned from a mix of typefaces and typographic variations, the logo reflects the diversity of the performance program. The individual letters of the logo, each with its own unique typographic personality, are distributed *dynamically* across the black background of the cover. To reinforce the concept, tinted photographs of the performers are masked inside the contour of each letter. A linkage is created between the typographic and photographic images. In keeping with its theatrical theme, the design is crisply typographic, visually challenging, and playfully kinetic.

Words and images are merged from front-to-back and side-to-side in Lee Willett's exhibition poster, *The Boat: Object and Metaphor* **(fig. 7-6).** Images appear to be located on parallel transparent planes, suspended in a broad expanse of sea and sky. Concurrently, sections and details of boats are abruptly juxtaposed against one another, creating the illusion of one larger boat on the primary picture plane. The eye moves restlessly around the poster, while the mind tries to comprehend the *metaphorical* meaning of the imagery. Willett works with extreme subtlety, carefully structuring the

Fig. 7-5. Vaughn Wedeen Creative, cover. Ovation Series, Popejoy Hall, the University of New Mexico, 1996.

Fig. 7-6. Lee Willett, poster, *The Boat: Object and Metaphor.* Pratt Exhibitions, Pratt Institute, 1995.

composition so that its full meaning is revealed only by thorough study. On the mundane level, the boat is a vehicle for moving about on water. As a *symbolic* vessel, or container, the boat is a metaphor for personal inquiry. The boat is also an object rich with association, reminding us of naval battles on stormy seas, piracy, whaling, clipper ships, and exploration.

Willett constructed his evocative boat from multiple images, using the technique of *photomontage.* The most chillingly powerful section of the montage, recognizable only upon close inspection, is the *plan view* of a slave ship, its human cargo systematically stowed away. Overlaying most of the poster is a delicately tinted nautical chart, which adds yet another layer of form and content, while performing double duty as an organizing *grid.* Willett built a relationship between the word *boat* and the image of a boat through *overlapping, proximity,* typeface selection, and typographic variation; set in lowercase Garamond Italic, the word *boat* has rounded, hollow shapes, reminiscent of boats or vessels, and the angle of the italic letters reflects the angle of the ship's sails. The attention flows from the words, to the image, to the infinite sky, in a seamless trajectory.

Jeff Neumann designed the cover of a *Seattle Times* special section spotlighting the opening of the Experience Music Project (EMP) rock 'n' roll museum **(fig. 7-7).** Neumann's disquieting design communicates on several levels at the same time. The reader is immediately engaged by the large, *silhouetted* photograph of a bleeding finger; not only is it intriguing, it's also strange, particularly in a newspaper and especially when rendered in such austere, moody colors. The color palette and the *biomorphic* shape of the

Fig. 7-7. Jeff Neumann, cover, special section. Experience Music Project, *The Seattle Times*, 2000.

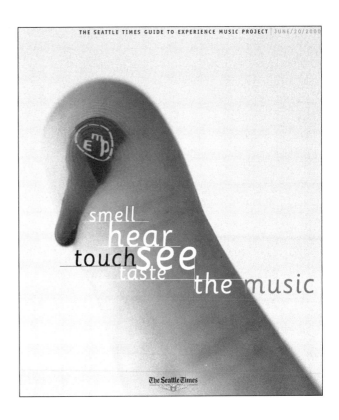

THE SEATTLE TIMES GUIDE TO EXPERIENCE MUSIC PROJECT | JUNE/20/2000

smell
hear
touch see
taste
the music

The Seattle Times

finger and its droplet of blood (pragmatically accentuated by the EMP let-termark) were influenced by the flowing design of the building itself. The bleeding finger also suggests the passion musicians and their fans have for rock 'n' roll; they "bleed" for the music.

A special characteristic of the museum is its hands-on methodology; visitors are encouraged to interact with the exhibits, not just look at them. Echoing that philosophy, a fluidly kinetic text block interacts with the image; like rock 'n' roll itself, the museum promises to engage *all* the senses. The reading hierarchy begins with the EMP mark, skillfully grafted to the blood oozing from the fingertip. From there, the eye drifts effortlessly on a downward curve, through the typographic listing of the senses, to the final, accented word *music,* strategically positioned at the lead edge of the page. Finger, blood, lettermark, and text are comprehended as one, reflecting Neumann's belief that rock music is a visceral experience, having to do more with the "gut" than the intellect.

Another way to integrate words and images is to use words *as* images. In the first decade of the twentieth century, artists/designers *El Lissitzky* and *Théo van Doesburg* (Russian and Dutch, respectively) created radically experimental books in which typesetting materials were employed to fabricate pictorial illustrations. Using letterpress furniture, *rules, slugs,* and a variety of typographic *sorts,* they explored the communication potential of abstraction

using color, form, and space in the *Constructivist* spirit. Concurrently, artists of the international *Dada* movement used bold typography, *vernacular* materials, collage, and photomontage in their effort to upset the norms of what they considered a failed society.

Lee Willett employed Dada and Constructivist techniques in his poster for a Dada Ball at Pratt Institute, cleverly composing text and photo images into a loopy Dada mask **(fig. 7-8).** The boldly reversed serif and sans serif letters of the word *dada* pop out from a dark, textured montage of distressed type and dissected photographs, forming the anatomical features of a face. Word and image are inseparable. The poster, designed for an audience familiar with and receptive to the historical and esthetic importance of Dada, is true to the Dada esthetic. By associating itself with the outrageously *avant-garde,* the Dada Ball achieves credibility and smartness (and promises a good time!).

David Ellis, Andrew Altmann, and Patrick Morrissey, partners in Why Not Associates, express their unique conceptual vision with fearless experimentation and exacting standards of design and production. Their exhibition poster, *Living Bridges,* for the Royal Academy of Arts, intimately associates word and image to create a commanding visual/verbal metaphor **(fig. 7-9).** The two-part exhibition featured examples of habitable bridges from medieval times to the present, as well as a competition section of design submissions

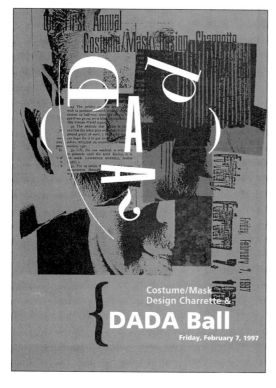

Fig. 7-8. Lee Willett, poster, *Dada Ball.* Pratt Institute, 1997.

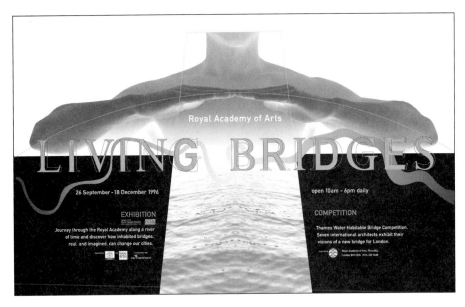

Fig. 7-9. Why Not Associates, poster, *Living Bridges*. Royal Academy of Arts, 1996. Photography, Rocco Redondo.

for an inhabited bridge to be built over the River Thames in London. The conceptual basis of the exhibition is that, in contrast to ordinary bridges, inhabited bridges are "alive." Why Not Associates expressed that hypothesis using words and images both independently and collectively. The title, *Living Bridges,* spans the width of the poster, bridging two black pylons separated by a deep, blue-green pool of water. The text *is* the image. Behind the title flows an amorphous, ribbonlike shape; played off against the typographic geometry, it brings life to the inanimate "bridge" of type. Looming over the entire panorama is a softly tinted, *metaphysical* figure, its arms forming a bridge of benevolent protection. When posted in an environment such as a tube station in the London Underground, the larger-than-life poster engages the audience physically, emotionally, and intellectually. As is often the case when graphic designers enrich a concept, the poster communicates beyond expectations.

The usually distinct boundary between verbal and visual communication is blurred in James A. Houff's poster for a typesetting company **(fig. 7-10).** Using the abundant visual vocabulary of his client's profession, Houff created a complex artwork in which words and images are densely compressed into an abstract composition. The audience of design and production professionals, who buy typesetting and *prepress* services, is visually sophisticated and receptive to pictorial experimentation. Houff mines the rich encyclopedia of imagery associated with the *typographic arts* and graphic production; individual letterforms, typographic text, photography, texture, video captures, printer's marks, and color are tightly interwoven.

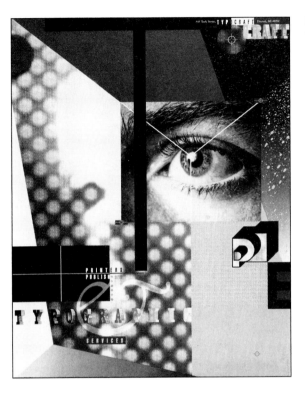

Fig. 7-10. James A. Houff, poster, *Type.* Typocraft Typographic Services, 1988.

Close consideration reveals a carefully organized layout, structured around the adventurously designed key word *type.* At the very top of the poster, a huge, black, architectural *T* on a brilliant red ground starts the eye moving. A reversed letter *Y* is next, the juncture of its arms centered over the pupil of a large *duotoned* eye. Below the *Y* is a flat field of *Ps,* upon which is positioned a dimensional *P* reminiscent of *foundry type.* Finally, in the lower right corner, replicating the visual treatment of the *T* at the top, is a bold sans serif *E* in red and black.

This word, embedded into the heart of the layout, is the conceptual and visual core of the design. In and around it, other elements provide more specific information and pictorial support. The upper right and lower left corners are occupied by the necessary informational text, such as the company name and contact numbers. This material, although kept in legible form, is also modestly pictorial; the nineteenth-century *decorative display* typeface references the historical roots of typographic design. Houff mirrored these two texts stylistically, anchoring the two corners and directing the eye diagonally, down and across the poster. To flesh out the allusion to the printing industry, familiar illustrative references, such as process ink colors, *halftone* dots, *tint* screens, *registration marks,* and special type characters, are strategically positioned throughout the poster. Houff's artistically sophisticated poster is the result of insightful analysis coupled with an adventurous orchestration of form.

Key Words—Vocabulary for Study, Discussion, and Critique

1. Abstraction
2. Advertising
3. Analysis
4. Art Deco
5. Avant-garde
6. Biomorphic
7. Chase
8. Chromolithography
9. Color palette
10. Commercial art
11. Constructivism
12. Content
13. Dada
14. Decorative border
15. Decorative display
16. Drafting
17. Duotone
18. Dynamic
19. Electronic format
20. Embossing
21. Formal design
22. Foundry type
23. Furniture
24. Graphic arts
25. Grid
26. Halftone
27. High contrast
28. Humor
29. Juxtaposition
30. Layout
31. Letterpress
32. Light sensitive
33. Lissitzky, El
34. Lock-up
35. Logotype
36. Meaning
37. Metaphor
38. Metaphysical
39. Methodology
40. Negative space
41. Overlap
42. Pantograph
43. Photomontage
44. Picture plane
45. Plan view
46. Prepress
47. Print format
48. Proximity
49. Publicity
50. Quoin
51. Registration mark
52. Research
53. Right reading
54. Rule
55. Silhouette
56. Slug
57. Sort
58. Symbolism
59. Synergy
60. Tint
61. Typographic arts
62. van Doesburg, Théo
63. Vernacular

8

Arrangement and Organization

Once the necessary elements for a project have been created, the designer arranges or organizes them in the working space. The arrangement of individual graphic components, and the space in which they are placed, is called the *layout*. *Gestalt* psychology points out that a composition comprised of separate elements is perceived first as a comprehensive unit; individual components and more subtle details of word, image, and space are examined secondarily. Therefore, the designer must devote attention not only to the constituent elements of a layout, but also to the larger, all-inclusive composition.

An esthetic organization of elements can improve the appearance and functionality of a project, attracting attention while providing direction and focus. Fortunately for the designer, there are many stylistic and functional approaches to layout. Some designers arrange materials intuitively, guided by their sensitivity to the size, shape, and content of adjacent elements, and a feeling for what is "right" for a specific assignment. Other designers arrange graphic material in a strict *hierarchy,* according to the relative importance of each component, and the precise order in which the content must be read. There are occasions when an orderly, *formal* approach to layout is inappropriate, and a deliberately discordant, *informal* arrangement of elements is more suitable.

When precise communication is a priority, such as a complex editorial, business, or technical document, an underlying architectural *grid* may be useful; the placement of text and image guided by standardized *columns,* *gutters,* and *margins,* which simplify the design process and unify the layout. Regardless of how a designer chooses to arrange graphic form, the appearance of the layout, as well as its content, communicates a very specific message to the viewer.

Arrangement and Organization

The content or precise purpose of a design project can influence the appearance of its layout. A *symmetrical* layout was used for the title page of

Fig. 8-1. Frontispiece of the first edition of *Primato Morale e Civile degli Italiani,*edited in Brussels 1843, by Vincenzo Gioberti. SEF / Art Resource, NY.

Vincenzo Gioberti's nineteenth-century treatise on moral philosophy and civil law, reflecting the serious academic nature of the book **(fig. 8-1).** In the simplest kind of symmetrical composition, graphic elements are distributed equally on each side of a vertical or horizontal central *axis.* In this example, both the typographic material and the *decorative border* are centered on a vertical axis. This manner of *type alignment* is logically specified as *centered,* and works best with discontinuous or short texts, such as headlines, sub-heads, or short paragraphs. A symmetrical layout is considered visually stable; components are evenly balanced, anchored by the central axis.

Because Gioberti's book addresses the weighty subject of moral philosophy, a balanced and "responsible" layout is appropriate. Enhanced by the use of a Modern Roman typeface, set in all caps, the layout concept is agreeably spare. The layout style and the typeface owe much to the work of Italian printer and type designer *Giambattista Bodoni* (1740–1813), who designed the Bodoni typeface, and whose *Manuale Tipografico* set the standard for typographic elegance. The Bodoni typeface features contrasting thick and thin *strokes,* hairline *serifs, vertical stress,* and narrow proportions. The successful printing of this severe typeface was dependent on an improved ink formula, harder type metal, and a smooth paper surface. The typeface and its accompanying *decorative devices* required impeccable *presswork* to capture

their crisp delicacy. Although the finely detailed decorative border, with its organic floral *motif,* is a pleasant contrast to the mathematical precision and formality of the type composition, its thick and thin engraved lines perfectly mirror the contrasting stroke weights of the typeface.

A much more elaborate example of symmetry is found in an early-fifteenth-century illuminated manuscript page by the Limbourg brothers, Dutch artists who were responsible for the design of spectacular books for the library of the Duc de Berry of France **(fig. 8-2).** The components of this incredible page, associating the signs of the zodiac with parts of the body, are arranged in *radial symmetry.* In this layout form, elements are positioned along guidelines that radiate out from the center point of the composition; in this example the center point is situated precisely at the groin of Anatomical Man. Guidelines radiating out from the center point govern the design of the surrounding calendar, with its meticulously placed text and astrological symbols. Horizontal texts are perfectly positioned in each corner of the page, reinforcing the symmetrical balance. Radial symmetry leads the eye in a reciprocal direction, from the center out, and back to the center. In this example, it also creates a circular movement around the outside perimeter, mirroring the orbiting rotation of the planets, the cyclical periods of the horoscope, and the passing months of the year.

Fig. 8-2. Limbourg Brothers, *The Anatomical Man.* Calendar miniature from the Très Riches Heures du Duc de Berry. 1416. Ms.65, f.14v. Photo: R. G. Ojeda. Réunion des Musées Nationaux / Art Resource, NY.

Fig. 8-3. Joseph Gering, institutional advertisement, *William Graham Sumner on the Conditions of Prosperity and Progress.* Great Ideas of Western Man series, Container Corporation of America, 1954–1956 series.

Although symmetry usually expresses stability, the arrangement of elements can be modified to generate *dynamic balance.* Joseph Gering, in his institutional advertisement for the Container Corporation of America, energized the symmetrical layout with a creative application of color and dimension **(fig. 8-3).** The advertisement, from the Great Ideas of Western Man series, presents a philosophical declaration by William Graham Sumner on the conditions required for prosperity and progress.

Sumner cites three conditions (industry, self-denial, and temperance) and Gering, the designer, uses this triadic concept as the foundation of his layout. He places three colored rectangles corner to corner on a white ground, each color-coded rectangle symbolizing one of the three conditions for prosperity and progress. As postulated in Gestalt psychology, even though the rectangles are different in color and size, our eye unites them into a more solid and architecturally unified Y-shape. Viewed separately, the shapes are neutral. Viewed as a whole, the Y-shape symbolizes the greater strength attained when all three principles are operating in concert. The symmetrical arrangement of forms also creates a triangular negative space, which becomes the focal point of the entire layout. This triangle is repeated in an overlying, elaborately complex sculpture, constructed of string wrapped around a geometric placement of pins. Without this structure, the layout

would be rather flat, plain, and less than dynamic. The sculpture, pho-
tographed in place over the painted rectangles, adds conceptual and visual
content; conceptually, the structure clearly demonstrates the importance of
a strong foundation; visually, the configuration and its cast shadow inter-
rupts the layout space, and adds visual complexity to the pristine layout. The
headline text, as expected, is set in a centered alignment, but the quotation
is unexpectedly set in a *flush-left* alignment, another subtle disruption of con-
ventional symmetry. Secondary text items, such as the series title, the de-
signer's name, and the corporate identification, are intuitively placed around
the periphery of the page, enhancing dynamic balance.

The vertically bisected, symmetrical layout of Lisa Graff's poster, *Make
All America a School,* is accentuated by its dramatically narrow proportions
and dark background color. As a result, the viewer's attention is focused on
the centrally arranged column of brightly colored graphic illustrations, sup-
ported at its base by a generously line-spaced text block **(fig. 8-4).** Since

**Fig. 8-4. Lisa Graff, Vaughn Wedeen
Creative,** poster, *Make All America a School.*
Jones Computer Network, 1994.

each illustration is skillfully positioned to just barely touch its neighbor, the visual integrity of the column is maintained. The screenprinted poster has a soft, velvetlike surface and a deep richness of color, impossible to achieve with any other print medium; the icons, each highlighted by a bright metallic outline, are overprinted on a beautifully controlled background gradient. Again supporting Gestalt theory, the viewer first reads the entire column as one, and then the individual icons. Metaphorically, the column of images demonstrates how the difficult "balancing act" of on-site education has been alleviated by innovative computer technology.

An *asymmetrical* layout, in which elements are distributed unevenly on either side of an axis, generates instability, movement, and dynamism. Cisneros Design's poster for the Genoveva Chavez Community Center demonstrates an exquisitely sensitive distribution of components in the working space **(fig. 8-5).** Although the graphic units on either side of center are quite different in size, shape, and color, the composition is *dynamically balanced.* The boldly stylized representation of the community center clings to the bottom right corner of the extremely horizontal layout space, its sweeping volume in stark contrast to the linear typographic treatment. There is a kinetic give-and-take from side-to-side; the reversed-out, geometric configuration of elegant sans serif text on the left, floating in a broad background of blue, balances the luxuriously colored architectural forms on the far right. This is possible because the words, although less visually aggressive, attract our eye as both readable information and visual form. When text is present in a layout, it demands to be read; its typographic form instantaneously draws the reader's attention. Even though the layout is *minimal,* Cisneros Design's careful adjustment of weights, densities, and spaces results in a serenely radiant, visually engaging poster. The precise refinement of form, exacting selection of color, and exceptionally fine print quality serve to articulate the community center's architectural merit.

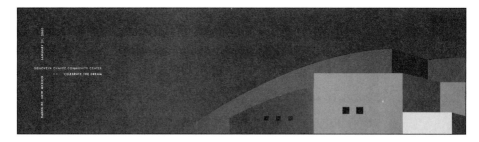

Fig. 8-5. Cisneros Design, poster. Genoveva Chavez Community Center, 2000.

The inventive layout of Bruce Licher's postcard announcing a benefit concert for Citizens Against Nuclear Waste in Nevada, is almost perfectly bisected by a vertical axis, and almost all the graphic material is contained on the left side of the composition **(fig. 8-6).** The card, or small poster, publicizes the appearance of "innovative musical artists Scenic and Space Management in unique and progressive multi-media performances." Licher's design is itself innovative, progressive, and unique, communicating experimental, positive energy. Intriguingly, the aerial photograph on the right-hand side of the card, and the layout process itself, are paralleled by the names of the bands, Scenic and Space Management. (The designer is managing space, the landscape image was photographed from space, and the aerial landscape is somewhat scenic.) The social and political cause supported by the benefit is also an issue of space management that ultimately affects Nevada's scenic landscape and quality of life. On the formal level, Licher uses type as line; text and rules encroach over the vertical boundary-line, "sewing" the two halves of the layout together. The result, superbly printed by letterpress, is smart and playful, yet replete with social and political meaning.

Publication designers (the designers of books and magazines) regularly design specialized *tabular* pages, such as tables of content, glossaries, bibliographies, and indexes. Often, the layout of these kinds of pages is governed by the textual contents of the document and the order, or hierarchy, in which the text is to be read. The table of contents of a manual designed by Vaughn Wedeen Creative for employees of U S West Communications addresses the

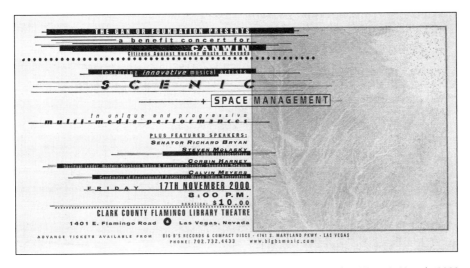

Fig. 8-6. Bruce Licher, Independent Project Press, postcard, *Citizens Against Nuclear Waste in Nevada*, 2000.

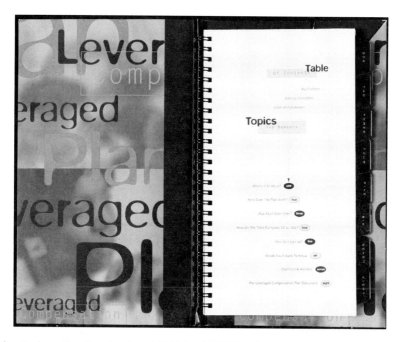

Fig. 8-7. Vaughn Wedeen Creative, *Employee's Guidebook.* U S West Communications, 1995.

special requirements of a contents page using both formal and informal design principles **(fig. 8-7).**

The page contains two general categories of information: a short table of contents, and a longer listing of topics contained in tabbed sections of the book. The information is structured in the typically logical order we expect, from general to specific. The two general categories are emphasized by color panels and Neville Brody's distinctive typeface, Blur. The rounded, "out of focus" *display typeface* is in bold contrast to the generic sans serif Letter Gothic used in the *tint panels.* The contents are arranged in a top-to-bottom hierarchy, starting in the upper right, angling to the center of the page, and coming to completion in the lower right.

Although the contents are listed in an orderly, sequential manner, the designer has introduced a subtle variation to the layout that brings a relaxed informality to the page. Finely articulated arrows and text containers help the reader follow the path of the text, which ends at the lower right corner, exactly where the reader will turn the page. A generous use of negative space, together with the diminutively sized sans serif typeface used for captions (Stone Sans), creates a strong contrast between the contents page and the more fluidly organic page it faces. Vaughn Wedeen Creative took an assignment most designers would consider routine, and fashioned an attractive yet functional solution.

Another method used to guide the organization and placement of graphic material is the grid, an underlying structure which subdivides the layout space with intersecting lines. The grid provides guidelines for the exact placement of elements, creates containers or frames to hold information, separates design components, and creates esthetically pleasing negative spaces. A layout grid can be visible, as in Alvin Lustig's advertisement for the Container Corporation of America **(fig. 8-8),** or it can be invisible, but implied, by the resulting mathematical relationships between visual elements. Lustig's layout is interesting for the way in which he used the grid to divide John Ruskin's statement about the benefits of education into discrete segments, with each portion set in a different typeface and point size. The simple, one-column grid enables Lustig to use a wide variety of typefaces while still maintaining a unified layout. In addition, the various typefaces serve double-duty as visual metaphors for the individuality of human souls, while also expressing in typographic style the meaning of the text. For example, the segment that says "and these two objects are" is set in a slab serif, dimensional typeface that reiterates the idea of "objects"; the segment containing the phrase "always attainable together, and by the same means" is set in the extremely condensed, modern roman typeface, Onyx, visually suggesting, through compression and repetition of form, "togetherness" and "sameness." The rectangular layout

Fig. 8-8. Alvin Lustig, public service advertisement, *John Ruskin: On the Benefits of Education.* Great Ideas of Western Man series, Container Corporation of America, 1954–1956 series.

grid also structures the hierarchical arrangement of the text, leading the reader from top to bottom in regular steps, while framing and stabilizing the irregular outer contour of the symmetrically typeset column.

Rudy VanderLans used a geometric arrangement of type containers for his poster announcing a series of new fonts (Base-12 and Base-9) designed by Zuzana Licko, his partner at Emigre **(fig. 8-9).** The typefaces were designed to address the need for a comprehensive family of fonts that could be used in both print and multimedia environments. The two-color poster is highly structured across the picture plane, the information charted in an almost scientific manner. Viewed from a distance, the reader sees vertically stacked text frames arranged on either side of a bisecting vertical fold, creating two loosely formed columns. The layout space is articulated using thick black outlines to define acid-green text containers on a white background. Heavy black bars connect the containers while subdividing the ground plane.

The reader, upon unfolding the poster, first sees, at the top left of the vertical fold, a well-organized specimen of the fonts, with a list of available variations. Arrows direct the eye to the right-hand side of the sheet, which contains samples of the typeface in outline and bitmap form. The name of the typeface appears in a huge, vertical setting in the middle left of the layout. A large text frame in the lower right corner describes the design problem and its subsequent solution, while anchoring the layout. Six illustrative

Fig. 8-9. Rudy VanderLans, poster, *Base-9, Base-12,* typefaces designed by Zuzana Licko, 1996.

panels are arranged vertically between the name of the typeface and the large text frame, numerically keyed to the text. Deep in the lower right corner, a black panel with reversed text contains useful definitions, *bleeding* off the edge of the sheet on two sides. VanderLans's layout concept is bold, aggressive, and spirited, but at the same time, well structured, practical, and supportive of the informational requirements of the assignment. Reflecting the innovative and thoroughly professional philosophy of Emigre, the poster is experimental in form, instructional in content, and intellectually rewarding.

The fall 1996 Emigre product catalog, *Integrating Life, Art and Business*, demonstrates how a *flexible grid* can enrich dynamic balance **(figs. 8-10, 8-11)**. Horizontal and vertical divisions are defined by hairlines and rules, subdividing the narrow, vertical format into two columns of unequal width. A wide column on the left, encompassed by grid lines, is reserved for text, while a very narrow column on the right is defined as negative space, used for the placement of icons and product pricing. Occasionally, photographs, order forms, or type specimens span the full width of the page, occupying both columns. The designer makes full use of the typographic variations available in Ottomat (Claudio Piccinini's featured typeface) to create *typographic color* on the pages.

Although the width of the columns is somewhat predictable, the column depth varies from page to page, dependent on the amount of space required

Fig. 8-10. Rudy VanderLans, Emigre, catalog, *Integrating Life, Art and Business*, typeface designed by Claudio Piccinini, fall 1996.

Fig. 8-11. Rudy VanderLans, Emigre, catalog, *Integrating Life, Art and Business,* typeface designed by Claudio Piccinini, fall 1996.

for text and visual material. Extremely bold horizontal *rules* are employed to define the base of each column, creating lively *negative spaces* of varying proportions that are either left empty or used for pictorial images. Throughout the catalog, icons symbolizing life, art, and business are inserted into the grid, sometimes intruding over grid lines, even overlapping the text itself. The result is an elegant and functional booklet that communicates good design while simultaneously toying with the traditional conventions of layout.

Devising original or inventive solutions to typical assignments is one of the pleasures of graphic design. Ann Marra's layout of a poster for the Cascade Run Off displays her interest in Asian design and *narrative* content **(fig. 8-12).** Rather than grouping elements in the center of the layout space, as is normally done, Marra unexpectedly pushes elements to the extreme outside edges of the sheet, leaving the center apparently empty.

However, upon a closer reading of the image, it becomes evident that the "void" is not only a powerful graphic shape, but also the space occupied by a runner. We, the readers, take on the runner's viewpoint of the race; we see the yellow line on the pavement, the grass along the edge of the course, the top of our running shoe, the back of the runner in front, and the intruding water bottle. By reversing the layout, Marra establishes that space is as real as physical form, that the two are interchangeable and interactive. As a result, our attention is magnetically attracted by the gridlike arrangement of

Fig. 8-12. Ann Marra Design, poster, *Cascade Run Off,* 1983.

logos along the outside edges of the poster. Marra's layout encourages us to read the race narrative and the logos concurrently, satisfying both race fans and sponsors. Her artistic approach to design results in a collectible poster that lives on long after the race is over.

Key Words—Vocabulary for Study, Discussion, and Critique

1. Asymmetrical (layout)
2. Axis
3. Bleed
4. Bodoni, Giambattista
5. Centered
6. Column
7. Decorative border
8. Decorative device
9. Display typeface
10. Dynamic balance
11. Flexible grid
12. Flush left
13. Formal (arrangement of elements)
14. Gestalt
15. Grid
16. Gutter
17. Hierarchy
18. Informal (arrangement of elements)
19. Layout
20. Lustig, Alvin
21. Margin
22. Minimal
23. Motif
24. Narrative
25. Negative space
26. Pattern

27. Presswork
28. Radial symmetry
29. Rule
30. Serif
31. Stroke
32. Symmetrical (layout)

33. Tabular
34. Tint panel
35. Type alignment
36. Typographic color
37. Vertical stress

9

Line

Line is one of the essential visual elements of graphic design. It can be imagined as the physical trail of a *point* (the most basic of graphic marks), moving in space. Designers use line in all its visual forms, such as thick and thin, straight and curved, regular and irregular, vertical and horizontal, solid and dashed, and it can be represented in black, white, value, or color **(fig. 9-1).** Each form of line has its own personality; straight lines are more formal than curved lines, horizontal lines are more placid than vertical lines, and dashed lines are more active than solid lines.

In graphic design, the visual form a line takes is linked to its function. A particular type of line is chosen to fulfill a specific objective. In *graphic stylization* and *illustration,* lines are used to define the edges or *contours* of images. For *layout* purposes, line is used to divide the working space into discrete areas, separating or calling attention to particular bodies of information or visual images. Line is also used in layout to enhance *hierarchy* and to lead the eye in a specific *direction*. In *typographic design,* text type itself is *linear* in form, an *underline* is occasionally used to emphasize important ideas, and *rules* and *hairlines* are used to divide paragraphs of text. Supporting graphic elements such as *ornaments, dingbats* and *decorative* borders are often created in line, for its strong graphic effect and printability.

Lines are created in a variety of ways, often dependent on the type of line required and the means of graphic production. Expressive lines may need to be drawn by hand, while geometrically accurate lines may be more efficiently created on the computer. Ultimately, of course, lines are integrated with all the other elements that constitute the final project. As with each of the other elements of graphic design, the designer orchestrates line to achieve esthetic and functional success.

One of the most prevalent uses of line in graphic design (aside from graphic illustration) is found in layout. In figure 9-1, line is used in a variety of ways to help organize the content of the diagram. In the beginning stages of design, even in electronic design for the Internet, the typical layout space

an inventory of lines

• a line can be visualized as the physical trail of a point, moving in space.

THICK AND THIN

STRAIGHT AND CURVED

REGULAR, IRREGULAR

HORIZONTAL, VERTICAL

SOLID AND DASHED

BLACK, WHITE, VALUE, COLOR

Fig. 9-1. An inventory of lines.

is an undifferentiated rectangle. Once words and images are placed in the layout space, a natural organization of material becomes evident; certain elements have to be positioned in a particular order and in a specific location. To enhance this categorical organization in figure 9-1, lines are used to create gridlike cells, or compartments, that facilitate the orderly containment of content. Line is also used to sequentially direct the reader's eye from one section of the diagram to the next. Reading starts in the lower left corner, where an arrowed line directs the eye upward to the title "an inventory of lines." The title itself is also linear; it continues to direct the eye to the upper left corner of the layout, where a right-angled line leads the reader to a single horizontal line of text, moving parallel to the top edge of the page. The long line of text is reinforced visually and conceptually by the parallel lines immediately below.

In addition to its use in the organization of space, line can also be used to illustrate form in a descriptive manner. When the predominant print process was letterpress (see chapter 2), illustrations had to be made in linear form, engraved or etched into the surface of type-high blocks, and printed along with type matter. Illustrators exploited the full range of linear possibilities, creating the illusion of tone and intermediate value using parallel lines, stippling, crosshatching, and lines of varying thickness. The resulting images, used to illustrate everything from newspapers and catalogs, to scientific volumes, are prized today for their graphic clarity, intricate detail, and ease of printing. Line art is a versatile form; used in black on white to take full advantage of its powerful graphic contrast; in monochrome for a more subtle effect; or in color, easily added to open areas of the illustration, or underlying the linear artwork **(fig. 9-2).**

Antique printer's ornaments are an example of how straight and curved lines of varying weights can be used to define form in a decorative manner **(fig. 9-3).** Printer's ornaments, as the name implies, were employed to augment the visual appearance of a page. They were made available for purchase by job printers, through widely distributed specimen books (and remain available today in book and CD collections). Their relationship to content is tenuous; at best, they are used to suggest or enhance the mood of a piece, rather than for their illustrative content.

In fig. 9-3, the filigreed, *symmetrical* ornament on the left sports a broad palette of beautifully articulated lines; heavily weighted lines define the primary form of the ornament, while animated lines of variable thickness delineate the *organic* foliage in the interspaces. The thick and thin lines form a sinuous and rhythmically spirited graphic device that will easily function in a typographic layout. The ornament on the right is more illustrative in form, featuring a highly stylized floral still life. Lines of varying weights are used to distinguish the component plant forms and establish a foreground/background dynamic. The stylized plant and vase are situated in a truncated rectangular

Fig. 9-2. Engravings, 19th century. *Animals: 1419 Copy-Right Free Illustrations of Mammals, Birds, Fish, Insects, etc.* Dover Publications, 1979.

Fig. 9-3. Engraved printer's ornaments, mid-19th century. *Pictorial Archive of Printer's Ornaments from the Renaissance to the 20th Century,* Dover Publications, 1980.

frame, the ninety-degree angles enhancing its compatibility with typographic design; like the varying stroke weights of type, the contrasting line weights of the printer's ornament sparkle on the printed page.

Graphic designer and limited-edition printer Bruce Licher creates intricate contemporary designs using the raw materials typically found in a print shop (such as foundry type, rules, decorative borders, and antique *advertising cuts*). The cards designed by Licher for his printing, graphic design, and CD packaging business, Independent Project Press, demonstrate how line can be utilized in both a functional and a decorative manner **(fig. 9-4).** First, the extremely horizontal format of each card is itself linear, the relationship of width to height roughly 2.5:1. Second, the *measure* specified for the typesetting is rather long, creating horizontally stretched lines of type that run parallel to the length of the cards. The use of a bold sans serif typeface, set with generous *letter* and *word spacing,* further contributes to the length of line. Finally, Licher underscores the lines of text with decorative rules and borders, again accentuating the linear proportions of the card. Printed on industrial-looking chipboard, each card displays the deep embossing, dense ink coverage, and organic texture associated with letterpress. The meticulous typography, detailed fabrication of decorative borders, and not least, the impeccable print quality elevate these pieces beyond their modest utilitarian function.

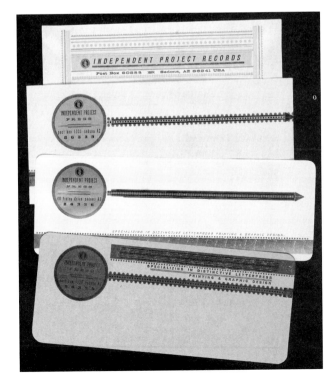

Fig. 9-4. Bruce Licher, self-promotion postcards. Independent Project Press, 2001.

Graphic stylization is an editing process, applied to pictorial images, that results in a boldly simplified, linear representation that works well with words and other images. To create the sharply stylized, black and white icon used to publicize a print symposium emphasizing photographic processes, the author started with pictorial reference materials, gradually stripped away unnecessary detail, then emphasized and exaggerated the underlying structure of the image **(fig. 9-5).** Line was used to define edges, describe detail, and imply dimension. The resulting *schematic* representation, crafted with lines of differing weights, is a careful balance between pictorial description and "design for design's sake." The highly abstracted form represents an *elevation view* of a vertical *copy camera*, showing the optical lens, bellows, and copy board. On the copy board is a cross-section of a *light-sensitive photo emulsion*, being exposed by light. The narrative content of the schematic illustration describes the photographic theme of the print symposium. A linear stylization such as this one is effective at different sizes, and the clearly outlined shapes can be easily filled with black, value, texture, or color.

Like stylizations, letterforms are highly refined symbols, denoting the sound elements of language. Hand-drawn or computer-generated letters can be represented in solid or outlined form, easily filled with value, color, or texture. The outside wrapper of issue 48 of the design and typography journal, *Emigre,* introduces a new typeface with Emigre's typical stylistic flair **(fig. 9-6).** The layout of the wrapper features oversized typographic letters, in solid and outlined form, that float dramatically over a black ground.

Fig. 9-5. Louis Ocepek, poster icon, *Photo Methods.* Seventh Print Symposium, Montana State University, 1984.

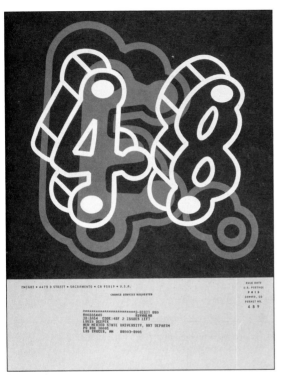

Fig. 9-6. Rudy VanderLans, cover design, typeface design, Elliott Peter Earls. *Emigre 48,* 1998.

Although at first the cover design seems simplistic, the design concept is actually quite experimental, and may be seen as an inquiry into communication theory. The number 48, set in Elliott's Typhoid Mary 3D Light, is highlighted by a broad, reversed-out white outline. The brightly outlined numerals overlap, and are in stark contrast to the solid blue letter *E* (for *Emigre*), set in Elliott's Typhoid Mary 3D Dark. The layering of the reversed numerals over the blue *E* forces the reader to perceive the issue number and the initial letter concurrently, thereby defying the normal convention of setting text parallel to the picture plane, in a linear, sequential manner. The intense white outlines, pushing forward, separate from the solid blue *E* and the black ground plane, suggesting the interaction of time and space. A simple use of line advances a design concept of enormous implication; the normal two-dimensional layout space is expanded into at least the third dimension.

Lines are found everywhere in daily life; they are used to demarcate or subdivide areas such as parking lots and playing fields (yard markers, end zones, base paths), streets and highways (centerlines, crosswalks, parking spaces), and ticket and registration lines. Lines of a different type are used for transmission, such as power lines, water lines, and telephone lines.

Line, which is greater in its lengthwise dimension than in its thickness, forces the eye to move in a linear direction. The pioneering *modernist* designer, Lester Beall, exploited the directional potential of line in his design

Fig. 9-7. Lester Beall, institutional advertisement, *Horace Mann on Achieving Greatness.* Great Ideas of Western Man series, Container Corporation of America, 1956–1958 series.

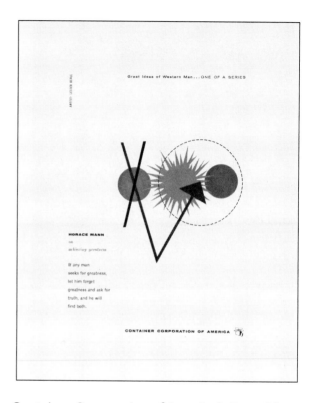

Great Ideas of Western Man...ONE OF A SERIES

HORACE MANN

on

achieving greatness

If any man
seeks for greatness,
let him forget
greatness and ask for
truth, and he will
find both.

CONTAINER CORPORATION OF AMERICA

for an advertisement in the Container Corporation of America's Great Ideas of Western Man series **(fig. 9-7).** His *minimalist* layout and use of directional line encourages the reader's eye to move laterally between text and image. Carefully placed horizontal and vertical lines of text create a generous negative space, accentuating Beall's skillfully abstracted composition of lines and shapes, that symbolize Horace Mann's words on greatness and truth ("If any man seeks for greatness, let him forget greatness and ask for truth, and he will find both"). A blue disk symbolizes greatness, negated by the red and black lines that cross its surface ("forget greatness"). The red line becomes an arrow, pointing to a large outlined circle on the right, containing a sunburst and a green disk. The sun symbolizes truth ("ask for truth"), and now a green disk represents greatness. Linked together inside the circle, they complete the narrative ("and he will find both"). Beall's dynamic orchestration of boldly primitive shapes, bright primary colors, and dynamically angled lines attracts attention while playfully enhancing communication.

Letterforms are fabricated from line, and so, in typographic design, line and content are one. The linear articulation of a letter creates an abstract representation of a sound as well as a highly refined graphic icon. Elisabeth Charman's advertising design for the digital type foundry, Emigre, illustrates how the distinctive linear configuration of letters can be utilized to structure a layout space and provoke visual interest through abstraction **(fig. 9-8).** In

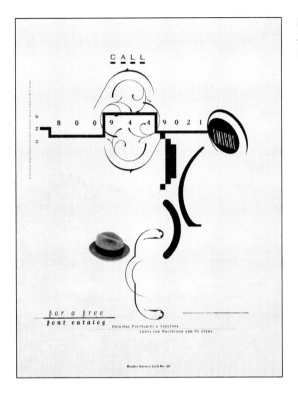

Fig. 9-8. Elisabeth Charman, magazine advertisement, typeface design, Miles Newlyn, Zuzana Licko. Emigre, 1992.

abstraction, information is, by definition, altered in form or stripped down to the essential. In order to use abstraction in advertising design, where communication is so important, the designer has to know his or her audience well. The designer of the Emigre ad could work confidently with abstraction, because the ad was to be placed in magazines tailored to design and graphic arts professionals committed to typographic design and appreciative of the abstract character of letters.

The black and white ad features dissected elements of Emigre fonts throughout, most noticeably the delicate Gothic flourishes of Miles Newlyn's *Missionary* and the chunky blocks of Zuzana Licko's *Lo-Res.* The purpose of the ad is simple: to encourage people to call for a free catalog. The product is type, and the imagery, with the exception of Emigre's signature fedora, is typographic. The sharp, crisply linear black strokes seem to cut into the white ground plane of the layout space, carving a rhythmic path from top to bottom. Space is an active element of the layout, with special attention placed on the interaction of positive and negative shapes. Depth is suggested by the dramatically contrasting line weights and the canted Emigre logo. The advertisement proves that the best way to promote a type foundry's product is to use the product well.

When line is juxtaposed in contrast to other graphic elements, such as shape, its distinctive visual character is accentuated, and the potential for

Fig. 9-9. Cisneros Design, identity mark. Santa Fe Film Festival, July 2000.

visual *synergy* is heightened. A dynamically energized layout can be created by manipulating the differences between elements, rather than their similarities. Cisneros Design contrasted line against shape in its intriguing identity mark for the Santa Fe Film Festival, elevating both the visual and the conceptual level of the mark **(fig. 9-9).**

On the linear side, a precisely balanced *S* is crafted of two perfectly mirrored, interlocking black lines, circumscribed by a boldly outlined circle. Simultaneously, a secondary *S* is created in the perfectly delineated negative space between the interlocked lines. To create a more intellectually stimulating mark, Cisneros Design expanded the design concept, contrasting the sharply linear lettermark with its softly toned "shadow." At first glance, the shadow appears to be that of the *S,* but immediately, the viewer realizes it is actually the shadow of an invisible film reel. Made more conceptually satisfying and memorable by this clever use of illusion, the design is visually distinguished by the expert interplay of line, shape, and tone. The mark is completed by the signature text of the film festival, centered beneath the shadow, set in Emigre's Triplex Sans Bold. The linear *S,* the soft gray shadow, and the text are vertically stacked and centered, in a dynamic *ABA* arrangement (A = black, B = gray, A = black, and A = line, B = shape, A = line).

Key Words—Vocabulary for Study, Discussion, and Critique

1. ABA (layout)
2. Advertising cut
3. Contour
4. Copy camera
5. Decorative border
6. Dingbat
7. Elevation view
8. Graphic stylization
9. Hairline
10. Hierarchy
11. Illustration
12. Layout
13. Letter spacing
14. Light-sensitive printing plate
15. Line
16. Line spacing
17. Linear
18. Measure
19. Minimalist
20. Modernism
21. Organic
22. Ornament
23. Point
24. Rule
25. Schematic
26. Symmetrical
27. Synergy
28. Underline
29. Word spacing

10 Shape

Shapes are *two-dimensional* elements, the contours of which are defined by closed paths. Shapes are *planar,* their surface oriented parallel to the *picture plane* **(fig. 10-1).** Shapes fulfill a variety of purposes in graphic design. They can be used in a *nonobjective, abstract,* or *pictorial* manner. Nonobjective shapes are simple in form, neutral in content, and devoid of precise meaning, often functioning as background panels or decorative devices. Abstract shapes are extremely stylized, bearing an iconic resemblance to pictorial imagery. Evocative in form and content, abstract shapes are useful in the design of *signs* and *symbols.* Pictorial shapes retain the outer contour of their image source, making them especially appropriate as *pictographs* and simplified illustrations.

As a two-dimensional element, a shape's appearance is determined by the visual treatment of its surface and contour. When filled with *solid color, tint,* or *texture,* shapes can be used as *text panels, silhouettes,* or *decorative* elements. A shape can be made more emphatic by outlining its outer contour, or edge, with a *stroke* of solid color, tint, or texture, in *harmony* or in *contrast* to its *fill.*

Shape is usually thought of as a positive form located in an empty layout space or on the picture plane. However, shape is also found in the delineated spaces between shapes, commonly called *negative space.* A carefully considered correlation between positive and negative shapes enhances the design concept while energizing the layout. The interior surface of a shape itself can be pierced by negative spaces, in the form of windows or voids. Individual letterforms, such as the lower case letter *e,* are particularly dependent on their *counter forms,* or negative spaces, for identification and readability. Designers work with shapes individually or, when a more complex treatment is desirable, in various combinations. Shapes are such a versatile design element that the full gamut of shape styles can be used in a single design project.

Some nonobjective, minimalist shapes, although simplistic in form, are nonetheless recognizable through repeated exposure. For example, even without words, we habitually read the most basic traffic signs. The shape of the

an inventory of shapes

- a shape is a two-dimensional, planar element, the contour of which is defined by a closed path.

PLANAR

DIRECTIONAL

REGULAR, IRREGULAR, AMORPHOUS

SILHOUETTE

COMPOUND

POSITIVE, NEGATIVE, FILLED

Fig. 10-1. An inventory of shapes.

sign acts as a *signifier,* triggering the appropriate response. Even the most rudimentary shapes, such as squares, circles, and triangles, suggest feelings of stability, warmth, and tension, respectively. Of course, a more precise expression of meaning or emotion through shape can be enhanced and clarified with the addition of color and text. The stop sign, for example, communicates its message using shape, color, and text concurrently **(fig. 10-2).**

Herbert Bayer, renowned artist, designer, and typographer, used nonobjective, *amorphous* shapes in his layout of an advertisement for the Container Corporation of America's Great Ideas of Western Man series **(fig. 10-3).** On one level, the fluidly animated shapes, informed by Bayer's modernist paintings, prints, and drawings, function as text containers for a Ralph Waldo Emerson quotation which defines the qualities of a civilized nation. On the other hand, the smoothly articulated shapes are used to direct the eye from the beginning of the text to the end, the divided content "dripping" from one amorphous container to the next, from the top of the layout to the bottom. The sleek, sharply delineated shapes, in dramatic green, red, and black, are asymmetrically balanced against a softly tinted portrait of the writer and philosopher. The oval shape of the portrait carries on the round-shape vocabulary used throughout the layout. All the shapes are in sharp contrast to the stark white ground, heightening the articulation of the negative space and sharpening the reader's focus. Bayer's design utilizes shape for its powerful visual effect, as well as its ability to divide, contain, and direct.

Fig. 10-2. Shapes, signs, and symbols.

Fig. 10-3. Herbert Bayer, institutional advertisement, *Ralph Waldo Emerson on a Civilized Nation.* Great Ideas of Western Man series, Container Corporation of America, 1951–1952 series.

Relative to nonobjective shapes, the precise meaning of which is largely ambiguous, silhouettes have the capacity to convey specific subject matter. The success of a silhouette is dependent on the visual acuity and drawing ability of the designer. The anonymous designer of these attractive cut-paper designs portrays familiar subject matter with precisely detailed contours and a minimum of interior rendering **(fig. 10-4).** The ability to confidently articulate negative space is critical in cut-paper design; the artisan must be not only technically adept, but also a sure-handed editor of form.

A pictorial silhouette was used for the cover of the portfolio, *Distinguished American Women,* designed by Push Pin Studios for the United States Information Agency **(fig. 10-5).** Despite the economy of means, the boldly simplified, monumental profile of a seated woman is easily read. The woman, lamp, and vase are sturdy, primitive shapes inked in solid black with sparse, white highlights. The black silhouette contrasts sharply with the ground plane and its trapped negative spaces. A reversed (white on black) floral design is pasted up with the inked profile, creating the woman's embroidered shawl and the large decorative rug at the bottom, which doubles as a background panel for the title text. Push Pin's characteristically *eclectic* design, refreshingly expressive in execution, is the epitome of the term "graphic": bold, clearly expressed, and essential in form, it is reminiscent of the black cut-paper silhouette-portraits that were once a popular art form. The illustration also

Fig. 10-4. Anonymous, cut-paper designs, *Insects and Vegetables,* China, 1971.

Fig. 10-5. Seymour Chwast, Push Pin Studios, portfolio cover, *Distinguished American Women.* United States Information Agency.

makes oblique reference to James Abbott McNeill Whistler's famous paint-ing of 1871, *Arrangement in Black and Gray: The Artist's Mother.* Founded by Milton Glaser and Seymour Chwast, Push Pin Studio's exuberant exploration of widely diverse art forms, including the *vernacular,* has energized graphic design from 1954 to the present.

Designers rely heavily on shape to create memorable symbols, pic-tographs, and logotypes. With repeated exposure, the audience learns to rec-ognize an identity mark, at least in part, through its unique shape. Kilmer and Kilmer, Brand Consultants, crafted a mark for Grace Church School using in-terlocking positive and negative forms **(fig. 10-6).** Even a quick glance at the mark reveals two primary forms, a very bold letter *G,* (the initial letter of Grace Church School) and a combined church and school building. The ab-stracted letter is black, its distinctive shape defined primarily by its outer contour. Within its broad black surface is a reversed-out church and school, which also serves as the negative counter form of the letter *G.* The entire mark is constructed of shapes: positive and negative, abstract, symbolic, and pictorial. As a result of Kilmer and Kilmer's masterful integration of form, the mark fulfills the design ideal of *concurrent communication*—the viewer com-prehends letter, image, and content simultaneously.

Push Pin Graphic, a publication of the immensely influential Push Pin Studio, provided a playing field for graphic experimentation. Subscribers ea-gerly anticipated each new issue, unique in design and content. Seymour Chwast designed issue number 52, dedicated to the writings of Dante, as a folded sheet, featuring a poster on one side and Canto XVIII, from *The Inferno,* on the other **(fig. 10-7).** *Ironic* humor, one of Chwast's signature attributes, is displayed in the poster's title, "Visit Dante's Inferno. The End Place." The copy makes Dante's Inferno (a vision of hell) sound like the name of a hot new club, and "The End Place" makes reference to the vernacular idiom, "It's

Fig. 10-6. Kilmer and Kilmer, Brand Consultants, identity mark. Grace Church School, 1986.

Fig. 10-7. Seymour Chwast, poster, *Visit Dante's Inferno. The End Place. Push Pin Graphic 52,* 1967.

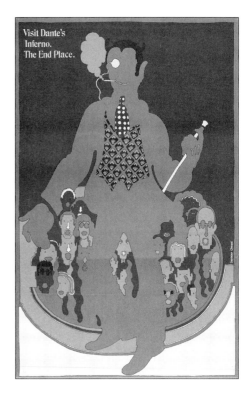

the living end, man," meaning the best, the greatest, the ultimate. Of course, in Dante's text, the Inferno is, literally and figuratively, the end place!

The poster's content is straightforward, a depiction of the Inferno and its suffering inhabitants. The simplified graphic shapes of Chwast's stylized figures are outlined with his distinctive freehand line, and filled with flat colors. Almost all the figures within the circle of hell are positioned parallel to the picture plane, giving the poster a crowded, two-dimensional feeling of psychedelic claustrophobia. The "host" of Dante's Inferno is the focus of the poster, decked out in patterned tie and vest, sporting the monocle, gloves, and cane of a dandy. This central figure is essentially an extra-large, beautifully contoured negative shape punched out of the dark blue background. Chwast's palette is appropriately fiery, the shapes filled with hot pink, orange, and yellow. Between the stacked figures, dark blue negative shapes push forward to the frontal plane, forming a parallel abstract design. Chwast's poster, to use the jargon of the 1960s, is a trip.

Like the previous examples, Vaughn Wedeen Creative's sizable poster, *For the Wheels of the Mind,* utilizes a dramatic shape on a contrasting background **(fig. 10-8).** In this case, however, the exaggerated image (of a tricycle) has considerable interior detail, and its contour extends (*bleeds*) beyond the edges of the sheet. The tricycle fortifies the poster's title and subtext: "the wheels of the mind," "children on their educational journey," and "helping

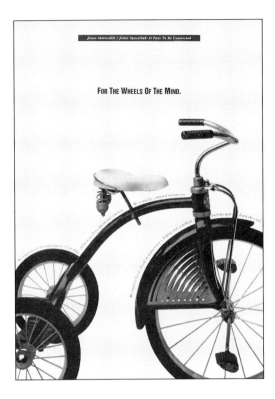

. . . students well down the road." The designer downplays the photograph's detail, emphasizing the shape aspect of the tricycle by *posterizing* the halftone and printing it in only two colors. To accentuate the flat shape even more, the trike was cropped on three sides, which pushes it forward, so the foremost wheels appear to be parallel to the flat picture plane. A subtle typographic design reinforces the tricycle's shape, italic text "travels" along the curved contours of its wheels and frame. Skillful manipulation of form efficiently unites intelligent copywriting with essential image, creating a classic poster design.

Key Words—Vocabulary for Study, Discussion, and Critique

1. Abstract
2. Amorphous
3. Bleed
4. Concurrent communication
5. Contrast
6. Counter form
7. Decorative
8. Eclectic
9. Fill
10. Harmony
11. Ironic
12. Negative space
13. Nonobjective
14. Pictograph
15. Pictorial
16. Picture plane
17. Planar
18. Posterization

19. Sign
20. Signifier
21. Silhouette
22. Solid color
23. Stroke
24. Symbol

25. Text panel
26. Texture
27. Tint
28. Two-dimensional
29. Vernacular

11

Value and Texture

Value and *texture* are visual phenomena that impart surface quality, volume, and weight to graphic form.

Two-dimensional forms, such as letters, nonobjective shapes, decorative elements, and graphic stylizations, are often rendered using *flat* values, textures, or tints of color. When a realistically detailed volumetric rendering of an object is needed, the *continuous tone* of a drawing, painting, or photograph is more suitable. Whether in flat or modulated tone, value and texture facilitate the spatial positioning of design components, enhance the appearance of visual elements, and reinforce the structural organization of the layout **(fig. 11-1).**

Texture can be used to convincingly render the grainy surface quality of an image, or it can be used in a *decorative* manner to energize or activate the surface of a flat graphic element. Texture can also be utilized to create the illusion of flat value, or tone, dependent on the relative density of the textural markings.

Value and texture are created using a variety of digital, handmade, and mechanical techniques, each producing a unique visual effect; continuous tone images, such as photographs or rendered illustrations, are adapted to graphic application using *halftone screens, digital dithering,* or *conversion screens;* flat values are produced using tint screens, digital *fills,* and a variety of handcrafted and special effect techniques. Value and texture augment illustrative detail, expand the range of visual form, and heighten graphic distinction.

Precise *percentages* of flat value are measured on a *step-scale* of tints, from 100 percent (solid value or color), to 0 percent (no value or color). There are countless variants of value and texture that can be applied to graphic elements (type as well as pictorial images), each variation affecting graphic form, legibility, and content **(fig. 11-2).** The most common, and obvious, applications are black on white and white on black. These variations are high in contrast and produce a powerful visual effect. To achieve a more subtle appearance, black can be diluted with white to create gray values. A tint percentage of black (60 percent, for example) can be applied to a shape positioned on a white or a black ground, lessening the degree of contrast between

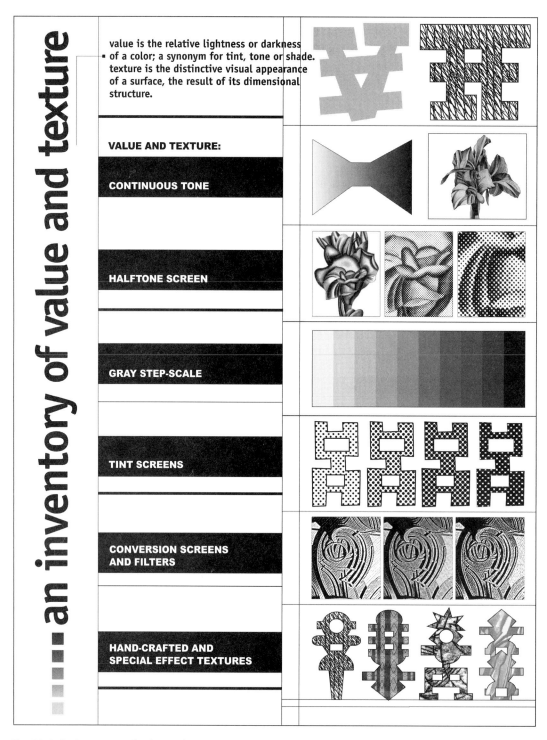

an inventory of value and texture

value is the relative lightness or darkness of a color; a synonym for tint, tone or shade. texture is the distinctive visual appearance of a surface, the result of its dimensional structure.

VALUE AND TEXTURE:

CONTINUOUS TONE

HALFTONE SCREEN

GRAY STEP-SCALE

TINT SCREENS

CONVERSION SCREENS AND FILTERS

HAND-CRAFTED AND SPECIAL EFFECT TEXTURES

Fig. 11-1. An inventory of value and texture.

Fig. 11-2. Orchestrating value and texture.

figure and *ground.* A tinted figure can also be *surprinted* on a tinted ground, resulting in an even more subtle relationship. The closer the two graphic elements are in value, the more subtle the effect (such as a 40 percent tint on a 50 percent ground); extremely close values affect legibility, which may or may not be desirable. Added to the many flat tint variants is the optional use of textured fills and backgrounds, expanding both communicative and decorative possibilities. The graphic marks used to create texture, such as the "worms" of a *mezzotint,* create the illusion of value, especially from a distance. Like value, texture can be implemented as solid color, a tint of color, light on dark, dark on light, and even texture on texture. The designer considers all the possible combinations of solids, tints, and textures, orchestrating the visual appearance of the layout for maximum effectiveness.

Flat tints and texture can be applied to images to help describe form, enhance volume, or provide decorative respite **(fig. 11-3).** When picturing three-dimensional objects, dark values are generally used to describe receding, shadowy areas, while lighter values are used to portray advancing, highlighted areas. When portraying a natural scene, for instance a deep landscape, certain atmospheric conditions such as excessive humidity or air pollution can cause these visual phenomena to be reversed, foreground elements being darker, while distant objects appear lighter. The greater the number of strokes per inch, the broader the stroke thickness, and the smaller the

Fig. 11-3. Using value and texture to describe form, enhance volume, and provide decorative respite.

space between the strokes, the darker the appearance of a textured area. Reducing the number of strokes per inch, using thinner strokes, and introducing more space between strokes reverses the effect, generating a textured area with a lighter apparent value. Before the advent of the personal computer, tints and textures were applied by hand (using conventional drawing and painting tools, or adhesive graphic arts films), or photographically (screening original artwork on a copy camera, using graphic arts conversion screens). Today, tints and textures are easily applied using specialized *graphic software*. Using *paint programs*, handmade textures are *scanned* and collaged into key artwork, conversion screens are applied using digital *screen filters*, and the *lines per inch* of halftones are manipulated using the desktop printer or film output device.

Text in its typographic form is one of the principal textural elements employed by the designer. Typeset text expresses value, texture, and content concurrently. Often overlooked by the designer, *typographic texture* is crucial to both form and function. As noted in chapter 5, the Latin origin of the word "text" is *texere*, to construct, and the origin of the word "texture" is *textura*, that which is woven. The interweaving of typographic variables (such as style classification, stroke weights, point size, width, and letter, word, and line spacing) affects the abstract textural appearance of type on the page or screen. Many typefaces are available in a broad range of weight variations, from light to bold. For example, the sans serif typeface Thesis TheSans, designed by Luc(as) De Groot, is available in extra light, light, semi light, normal, bold, extra bold, and black, providing the designer with a complete value range, from light to dark. Multiple Master fonts provide even more variations. The judicious application of these typographic options enables the designer to

enrich both the form and the substance of a design project, achieving diversity within a consistent typographic framework **(fig. 11-4).**

In addition to being used for graphic effect, texture can also be used to communicate a particular attitude. Ronnie Garver's self-promotion posters for *Toolbox Design* illustrate how texture contributes to the visual definition of a design esthetic **(fig. 11-5).** Garver's visual concept is an obvious spinoff of the "toolbox" theme: his featured tool is a fly swatter (or, in this case, tick swatter), each poster showing a different kind of "swatter—"a rolled-up newspaper, a boot, and a conventional fly swatter. The tall, narrow sheet size mimics the linear shape of the tool. Texture enhances Garver's *Dirt Culture* esthetic: gritty, documentary, irreverent, and wryly humorous. The artwork is either treated as *line copy* (reduced to high contrast, without the subtlety of tone made possible by screening) or it is very coarsely screened, using conversion filters. The text on the poster with the rolled-up newspaper (it's the want-ad section) is so distressed it reads as almost pure texture, rough and deliberately obscure. The anxious, textured appearance of the poster is germane for designers whose self-identity is (playfully?) defined as "graphic design freaks, layout fiends, and screen printing fools." There should be no doubt about what kind of work you'll get from *Toolbox Design*.

Prior to the invention of halftone and line conversion screens, which mechanically reduce values to a prescribed set of black dots, lines, or textures suitable for printing, engraving and lithography were the predominant means of pictorial reproduction. As demonstrated in figure 11-1, line conversion screens can be used to create the illusion of continuous tones. However, the conversion screen is actually a mechanical attempt to emulate the appearance of antique (or contemporary) copper and steel engravings. Engravers meticulously incise parallel, stippled, or crosshatched lines of varying thickness into metal plates. Ink is rubbed into the lines, the surface of the plate is wiped clean, and the plate is run through a press under enormous pressure, transferring ink from plate to paper. The title page of a King James Bible, printed by Robert Barker in 1611, reveals the incredibly rich range of value created by this amazingly labor-intensive technique; the sparse, symmetrical typography is in sharp contrast to the wide, densely illustrated border that threatens to engulf it **(fig. 11-6).** The ornamental figures in the extraordinarily intricate border are volumetrically rendered with almost geometric precision, belying the fact that the apparent value range is an illusion created entirely with line!

As discussed in Chapter 6, *stone lithography,* invented in 1798 by Alois Senefelder, is the historical forerunner of *offset lithography,* the dominant commercial printing process of our time. Lithography enabled the illustrator to produce and print images with continuous tones of value, using more or less conventional art tools. Drawing with greasy crayons and pencils on the surface of a tightly textured limestone slab, the artist could render images in much the same manner as on paper. After considerable chemical processing, the inked-up image

Fig. 11-4. Typographic value and texture. Typefaces: Nueva, Cheltenham, and Gill Sans.

Fig. 11-5. Ronnie Garver, posters. *Toolbox Design*, 1999.

Fig. 11-6. *The Holy Bible . . . Newly Translated out of the Original Tongues.* Title page to the New Testament, from the King James Bible. London: Robert Barker, 1611. PML 5460. The Pierpont Morgan Library / Art Resource, NY.

could be transferred to paper. Following the printing of a single impression, the stone was recharged with ink and the printing process repeated until the entire run, or edition, was complete. As with paper, the toothy surface of the stone was able to capture a full range of tones, from the blackest blacks to the lightest tints of value. In 1904, the German biologist and philosopher Ernst Heinrich Haeckel, with artistic and technical assistance from Adolf Giltsch, published a spectacular volume of lithographic plates illustrating art forms in nature **(fig. 11-7).** The meticulously detailed plates, drawn with extraordinary vigor, demonstrate the exquisitely subtle tonal range of the lithographic process.

Fig. 11-7. Ernst Heinrich Haeckel, Adolf Giltsch, scientific illustration. *Kunstformen der Natur (Art Forms in Nature),* 1904, Dover Publications, 1974.

There are occasions when, within a single project, a broad spectrum of value and texture options can be applied. Lee Willett masterfully integrated graphic expression with subject matter in his poster, *Seeing Multi-culturalism,* weaving them into a seamless whole **(fig. 11-8).** The poster, announcing an arts festival celebrating three world cities, operates equally well on both the intellectual and visual levels, logical in organization, expressive in effect.

On the organizational level, the concept of "three" becomes apparent. The festival is about three cities, and the poster is divided into three horizontal sections. The title is also divided into three lines, and the names of the three cities are emphasized on a white central ground. The concept of three is repeated in the informational text, three cities, three films, and three speakers. Virtually every aspect of value and texture is used in support of the urban, multicultural subject matter. A panel of dark, solid color at the top, together with a high-contrast photograph at the bottom, frames a central panel of white, on which the title appears. These dark upper and lower image areas pinch in on the central panel, creating a deep perspective that enhances the idea of "seeing" multiculturalism (perhaps in the sense of "seeing the light").

Fig. 11-8. Lee Willett, poster, *Seeing Multi-culturalism.* Pratt Institute, 1997.

The overall tonal range of the poster expresses a specific vision of the urban landscape—shadowy, moody, even a bit sinister (not unlike the film noir genre of the 1950s). Graphically textured photographic images are cropped inside the prefix "multi," reinforcing the emotional atmosphere. Blocks of informational text are reversed out of the flat, dark panel at the top, the weight variation of each block carefully articulated for visual effect and emphasis. The smart, professionally executed poster is eminently functional, the beautifully organized hierarchical layout enriched by the fullness of visual form.

James A. Houff's large poster celebrating the ten-year anniversary of Television By Design (TVBD) makes evident his masterful control of tonal elements **(fig. 11-9).** The layout is organized around the number 10, drawn from the phrase "the power of ten." The number is expressed in a variety of forms; the crossing strokes of a large Roman numeral X mark the center of the composition; the 0 from the conventional form of the number 10 is positioned at the axis of the Roman numeral, reinforcing the center point; the numerals 1 and 0 appear at the outer extremities of the Roman numeral; and a repeat pattern of 10s creates a textured background panel.

Intimately integrated with these numerical features are several other graphic elements: (1) The Roman numeral X is circumscribed by a square, and a word is situated on each side of the square, two placed vertically, and two horizontally. These four words (*attentive, potential, extensive,* and

Fig. 11-9. James A. Houff, poster, *The Power of Ten.* Ten-Year Anniversary, Television By Design (TVBD), 1993.

intensity) lend philosophical weight to the poster's message while influencing decisions regarding narrative, imagery, and graphic treatment. (2) Texture appears not only in the panel of 10s, but also in a hugely magnified, centrally located fingerprint, derived from the emblematic hand appearing at the top of the poster, symbolic of the humanistic role of the designer in Television By Design. (3) A moody, atmospheric *montage* of *photo-manipulated* hands, positioned on darkly muted tint panels, serves to integrate all the graphic elements, while making oblique reference to the creative mind and the design process. Houff achieves a remarkable equilibrium of word, image, and graphic treatment; each individual aspect, including value and texture, contributes to the narrative statement.

Key Words—Vocabulary for Study, Discussion, and Critique

1. Continuous tone
2. Conversion screen
3. Decorative
4. Digital dithering
5. Figure
6. Fill
7. Flat
8. Graphic software
9. Ground
10. Halftone screen
11. Letter spacing
12. Line copy
13. Lines per inch
14. Mezzotint
15. Montage
16. Offset lithography
17. Paint program
18. Percentage
19. Photo-manipulation
20. Scanning
21. Screen filter
22. Step-scale
23. Stone lithography
24. Surprint
25. Texture
26. Typographic texture
27. Value

12

Color

Color is the visual appearance of an object created by the specific quality of light it reflects or emits. *Primary colors* are the theoretically pure colors from which all other colors can be mixed. The colors, or *hues,* of a printed project, such as a poster, are created by the *reflection* of light from the paper the design is printed on, each printed image reflecting a particular range of the color spectrum. The hues visible on a *monitor* screen are created by mixing the color components of *transmitted* light in varying intensities, also forming a full spectrum of color. Color has three visual qualities: *hue* (its apparent, named color, such as red), *value* (its degree of lightness or darkness), and *intensity* (its degree of saturation or purity) **(fig. 12-1).**

The color model for print projects is called the *subtractive model.* In this model, *cyan, magenta, and yellow (CMY)* are the primary colors of reflected light, and are the ink colors intermixed to create the full spectrum of color. White light (as would be reflected from a white sheet of paper) is comprised of *red, green, and blue (RGB)* (added together, they create white light). In the subtractive color model, if an object (or image) absorbs (subtracts) red light but reflects green and blue light, the color you see will appear as cyan. If blue light is absorbed, the reflected color appears as yellow, and so on. In theory, when CMY are combined in print, they produce black. However, creating black by overprinting CMY requires too much ink, resulting in drying problems and extra expense. In practice, black is used to add density to the CMY image, thus the four colors are called *CMYK.* The letter *K* is used to signify black, so as not to confuse it with *B* for blue, and also because it is the key image plate, usually carrying the most image detail. Projects printed in CMYK are also called *process color, full-color,* or *four-color.*

The color model for *electronic* projects (those using transmitted light, such as a display monitor) is called the *additive model.* Transmitted light is comprised of red, green, and blue, or RGB. When full intensities of RGB are added together, the light appears as white. When no light is being transmitted, we see that area as black. Therefore, varying intensities of RGB are

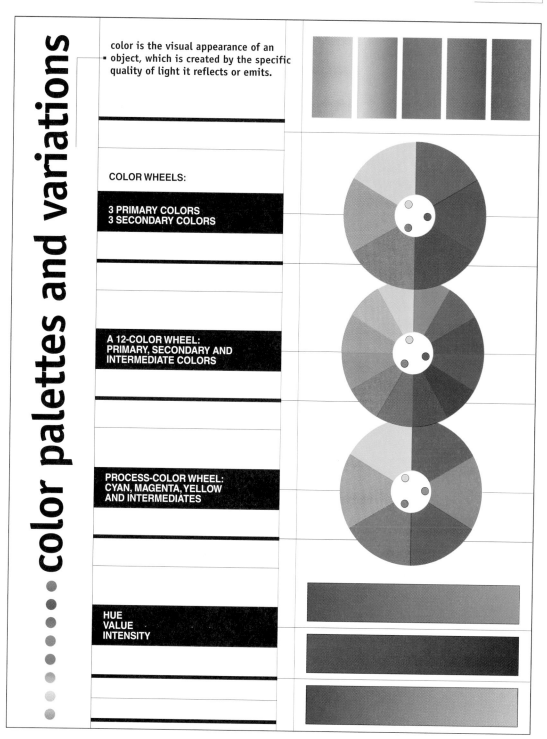

color palettes and variations

color is the visual appearance of an object, which is created by the specific quality of light it reflects or emits.

COLOR WHEELS:

3 PRIMARY COLORS
3 SECONDARY COLORS

A 12-COLOR WHEEL:
PRIMARY, SECONDARY AND
INTERMEDIATE COLORS

PROCESS-COLOR WHEEL:
CYAN, MAGENTA, YELLOW
AND INTERMEDIATES

HUE
VALUE
INTENSITY

Fig. 12-1. Color palettes and variations.

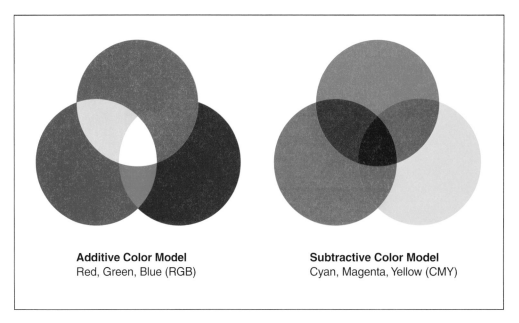

Additive Color Model
Red, Green, Blue (RGB)

Subtractive Color Model
Cyan, Magenta, Yellow (CMY)

Fig. 12-2. The additive and subtractive color models.

used to create the full color spectrum. When designing for the Internet, a reduced *(Web-safe)* color palette may be desirable to ensure consistent display **(fig. 12-2).**

The designer uses the color wheel, comprised of primary, *secondary,* and *intermediate* colors to create hue combinations appropriate to the content and character of a project. Different combinations of colors create varying degrees of visual contrast and affect the emotional ambiance of the design. Colors opposite one another on the color wheel, such as red and green, are called *complementary colors.* Depending on their value and intensity, *complementary pairs* can be high or low in contrast. Using an orange and green of the same value and intensity, for example, produces a high degree of visual vibration—hard on the eye, but appropriate for a "psychedelic" effect. Yellow and violet, on the other hand, are quite different in value, the violet significantly darker than the yellow, and can be used together without creating such a dramatic visual effect. *Triadic complements* are sets of three colors equidistant from one another on the color wheel, such as blue, green, and orange. With the addition of one more color, a wider range of color possibilities becomes available. *Near complements* are created by combining a color with the two colors on either side of its complement. A palette of near complements usually utilizes secondary and intermediate colors, such as orange with a secondary violet and blue, resulting in a more subtle visual statement. Complements can be superimposed in various combinations, for example dark on light, light on dark, blue on orange, orange on blue, blue on

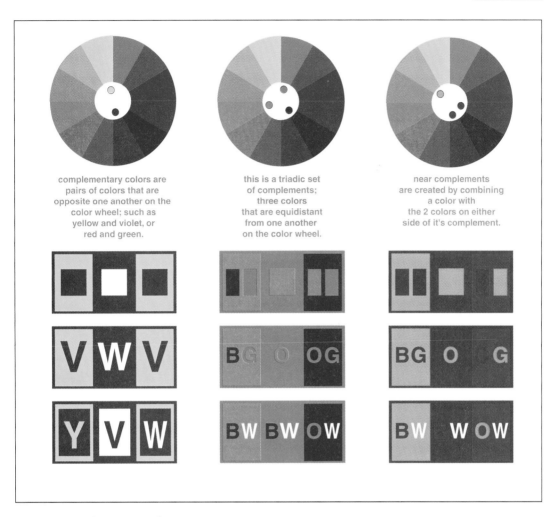

Fig. 12-3. Complementary colors.

orange on green, orange on blue on green, and so on. Two or more pairs of complements can be used together, as well as pairs of triadic sets. The possibilities are almost unlimited **(fig. 12-3).**

As mentioned above, color has three visual characteristics, hue, value, and intensity, and the designer exploits all three of these qualities. Even the most limited use of color offers these three possibilities. A one-color job using a *spot color* of red, for example, provides the designer with the solid, 100 percent red hue, which has a particular degree of intensity as well as a step-scale of tint percentages or values of the basic red, such as 80 percent, 70 percent, 60 percent, and so on. In a job using two or three spot colors, each individual color has this full range of value, or tints, and each color and its tints can be combined with each additional color, resulting in an extraordinarily comprehensive color

palette. Depending on the colors initially chosen, intermixing or overlaying colors and tints (*offset printing inks* are transparent) produces a value range from dark to light in the most subtle of neutral tints **(fig. 12-4).**

Color is universally employed to symbolize cultural ideals, social, political, and spiritual attitudes, and a broad spectrum of emotional and physical conditions. Colors gain their symbolic meaning through association, such as blood red to symbolize energy and life, the luminous yellow of the sun to express warmth, or leaf green to convey health and growth. Color is also used to express more esoteric states, such as violet to represent spirituality, or blue to communicate melancholy. Some colors are more visible than others, making them useful as signifiers, such as the familiar yellow used for school buses, the red of a stop sign, or the red, yellow, and green of a traffic signal. Social and political positions can be suggested using color, such as green for an ecological subject, or red to symbolize revolution. Color is used to improve the visual appearance as well as the communication level of a design.

The usefulness of color to the designer is, of course, in the effectiveness of its application. Using the color models discussed above, the designer has an enormously broad range of groupings from which to choose. The expressive range of color is vast; it can be passive or aggressive, and it can express quality or cheapness, strength or weakness, joy or grief. Each particular color combination influences the overall appearance and effectiveness of a design, while at the same time expressing a distinct attitude **(figs. 12-5, 12-6).**

Leo Lionni, a pioneering art director, graphic designer, and illustrator, emigrated from Italy to the United States in 1939. He used color as a key element in *Epictetus on Philosophy,* from the Container Corporation of America's public service series Great Ideas of Western Man **(fig. 12-7).** Lionni's design is based on an excerpt from Epictetus's *Discourses,* of the first century, "Here is the beginning of philosophy: a recognition of the conflicts between men, a search for their cause" The significant concept of the ad is "conflict resolution." Lionni's powerfully iconic design of three standing figures portrays a central, mediating figure, flanked by two armed combatants. The starkly black stylized figures, appearing to be roughly cut from black paper, like paper dolls, are a perfect foil for the intense primary and secondary colors that fill the negative spaces between the protagonists. The colors are used to express both difference and unity. Bright red-orange is linked to the left-hand figure, while bright green (the complementary color to red-orange) signifies the figure on the right. The dramatic vibration of the two complements, both aggressive in nature, serves to further isolate the adversaries. Concurrently, placing colors in the sharply defined negative spaces also helps to draw the three figures together, uniting them with a common backdrop. Enriching the concept further, two additional colors border the middle figure: bright yellow imparts a hopeful, positive attitude, while purple lends dignity

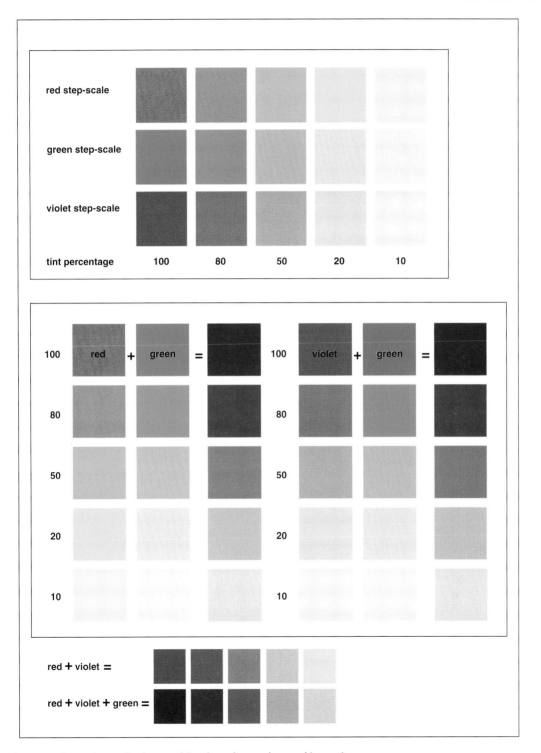

Fig. 12-4. Tint scales and color combinations; hue, value, and intensity.

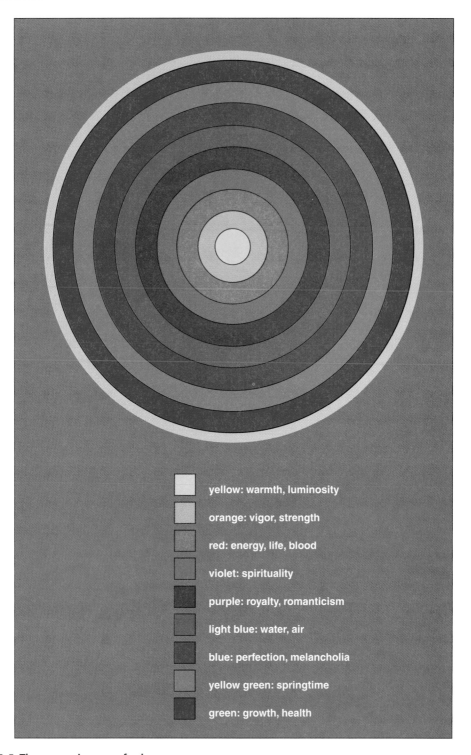

Fig. 12-5. The expressiveness of color.

Fig. 12-6. Applying color.

Fig. 12-7. Leo Lionni, institutional advertisement, *Epictetus on Philosophy.* Great Ideas of Western Man series, Container Corporation of America, 1951–1952 series.

and gravity to a difficult state of affairs. The appearance and the effectiveness of the design are improved with color.

Full-color printing, and, of course, electronic full color, is ubiquitous in our visual environment. Limited color, or less than full color, however, doesn't have to limit creativity. In fact, limited color actually stands out in contrast to the more familiar full color, and can be deliberately exploited for its uniqueness. Each year, Jeff Neumann, the designer of the *Seattle Times* entertainment tabloid, *Ticket,* has to create a cover for the summer concert issue. Each time, the challenge is to find another way to visually symbolize both music and summer.

For the 1999 cover, Neumann used color to smartly integrate word, image, and symbol in an unexpected way **(fig. 12-8).** The key to the cover design is Neumann's witty spin on the headline, "Shake and Bake" (the popular batter mix in a bag) and the subhead "The summer simmers with hot concerts." The predominant image, a sculptural black and white photograph of a woman, taken from the back, has been given a terribly painful sunburn, with a single music note skillfully reversed out of the red. The analogy is immediately clear: when you sit in the sun all day, shakin' to the music, you're likely to be baked to a crisp! Text, photograph, and music symbol are intimately united. The second color, cleverly added to the monochromatic photograph in a dramatic, yet understated manner, effectively reinforces the elegant simplicity of the concept.

For the summer 2000 cover of *Ticket,* Neumann used color in both a descriptive and a symbolic fashion **(fig. 12-9).** Titled *Cultivating the Classics,* the issue reviews summer classical music festivals around the state. The principal image, a beautifully decorative silhouette of a violin-playing idyll, establishes a classical aura while flowers emanating from the violin symbolize music. The silhouette, completely lacking interior anatomical detail, is filled instead with a flat pattern of green grass, simultaneously expressing both summer and the outdoors. The flowers, in contrast to the almost *monochromatic* grass, are full color, their form as rich, lyrical, and dimensional as the music they symbolize.

Just as color can be employed to express a mood or emotion, it can also be used to make evident certain social or cultural associations. René Galindo's cover design for *Diseño Grafico en Mexico,* a juried annual published by Quorum, a professional graphic design organization, unites form and color to exemplify Mexican design **(fig. 12-10).** The most immediate impression projected by the cover design is that of color; the entire wheel of primary, secondary, and intermediate colors is represented, each color intensely saturated for maximum effect. Complementary pairs contribute to a sumptuously rich palette, while soft tints are used to create a subtle third dimension. The color statement suggests Mexican folk art, wedded to the geometry of Aztec or

Fig. 12-9. Jeff Neumann, cover, *Cultivating the Classics. Ticket, The Seattle Times,* 2000.

Mayan architecture. The central image, heavily outlined in black, serves quadruple duty: a stepped pyramid, a technical pen or pencil, a modern skyscraper, a pixilated electronic design. Looking closer, one also sees the hot magenta sun, surrounded by a high purple sky, and, just beneath the horizon line, the bright green of the fertile earth. With each element firmly locked into place, the symmetrical design epitomizes the essence of classical graphic design.

The versatility of full-color printing is thoroughly exploited by designer Joe Erceg in his poster for a celebratory fireworks display **(fig. 12-11).** Touted as "A Theatre of Fire, Color and Sound," the project provided the perfect opportunity to link color exploration with subject matter. Erceg's insistently symmetrical poster is bright, playful, and energetic, somewhat reminiscent of a nineteenth-century *broadside.* The showpiece of the poster, a dazzling pinwheel of fire, explodes out from its center point, leaving waning trails of tiny colored stars in its wake. Four fireworks towers flank the central design, each carrying pinwheels on their armatures, the artwork saturated with various combinations of the process ink colors (CMYK). Erceg cleverly reversed the tone of the night sky, making it white rather than black *(achromatic),* simultaneously emulating the explosive white light cast by the fireworks, accentuating the radiant colors of the pinwheel, and silhouetting the awestruck children watching the show.

Fig. 12-10. René Galindo, Signi, book cover, *Diseño Grafico en Mexico, Volumen I.* Quorum, Consejo de Diseñadores de México, 1997.

The full-color technology of print and electronic media makes possible the emulation of "natural," or photographic color, as well as infinite tints and color combinations. Computer technology enables designers to profoundly alter real color to either enhance communication or create artistic effect. Rick Valicenti and Mark Rattin of Thirst Studio, uncompromising, passionate explorers of new directions in design, manipulate media in a celebratory spirit of graphic self-expression. In their collaborative poster, *Mother,* advertising an extended lecture and design workshop by Valicenti, conventional, full-color imagery is united with digitally manipulated form to create an enticingly abstruse visionary icon **(fig. 12-12).** A physically manipulated vernacular typeface is used for the background text, its rough-hewn texture in deliberate contrast to the smooth, full-color perfection of the heavily art directed fashion photo of "mother." Subjected to further processing in a *3-D modeling* program, the typeface reappears as an essentially monochromatic word sculpture, uncomfortably floating at, or on, the model's neck, tagging her as "mother." The forward-looking, emotionally detached figure drifts up and into the layout from off-camera, her torso rendered in smeary shades of full color, disturbingly biomorphic. Ingeniously, the designers melded conventional and experimental technology to create a stunningly memorable graphic entity.

Fig. 12-11. Joe Erceg, poster, *Fireplay*.
Twentieth Anniversary of Lloyd Center,
Portland, Oregon, 1980.

Fig. 12-12. Rick Valicenti, Mark Rattin,
Thirst, poster, *Mother*. Society of Graphic
Designers of Canada, Alberta Chapter, 1994.

Key Words—Vocabulary for Study, Discussion, and Critique

1. Achromatic
2. Additive color model
3. Broadside
4. CMY (cyan, magenta, yellow)
5. CMYK (cyan, magenta, yellow, black)
6. Complementary colors
7. Complementary pairs
8. Electronic media
9. Four color
10. Full color
11. Hue
12. Intensity
13. Intermediate colors
14. Monitor
15. Monochromatic
16. Near complements
17. Offset inks
18. Primary colors
19. Process color
20. Reflected light
21. RGB (red, green, blue)
22. Secondary colors
23. Spot color
24. Subtractive color model
25. 3-D modeling
26. Transmitted light
27. Triadic complements
28. Value
29. Web-safe palette

13

Pattern and Rhythm

Pattern and *rhythm* are interrelated actions, each reliant on the repetitious placement of individual graphic units in the layout space. The graphic units used to create pattern and rhythm vary widely in form and content, including illustrations, text blocks, photographs, supportive graphics (such as rules and hairlines), and decorative elements. Pattern and rhythm perform both a functional and a decorative function in graphic design, having a collective bearing on comprehension as well as visual appearance. To create pattern, *modular* units, or groups of units, are used in a regular, repetitious manner. Simple pattern making starts with a single sharply delineated graphic module, which can be pictorial, abstract, or nonobjective in form. To achieve the visual complexity of pattern, a critical mass of repeated units is required; the elements are then arranged in a highly structured manner, meticulously aligned horizontally, vertically, and diagonally to form a tightly woven *surface design*. To achieve a more complex effect, modules can be arranged in groups, which in turn are organized to create pattern. Value, color, and texture can be applied to modules, or to groups, to enhance visual appearance and establish emphasis within a layout **(fig. 13-1)**.

Rhythm occurs when graphic units, or groups of units, are repeated in a *recurring* or *alternating* fashion, rather than in the strictly *repetitious* manner of pattern. Certain units, accentuated by recurring variations in size, spacing, and graphic treatment, enrich the visual form while creating a *syncopated* sense of movement. Particularly when size variation is employed to generate *cadence*, rhythm ensues not only across the two-dimensional surface of the picture plane, but from foreground to background as well, enabling the designer to exploit the full potential of the layout space. Compositional rhythm can be regular in its repetition of "beats," analogous to a 4/4 *meter* in music, or it can be less predictable, lending a more aggressive movement and dynamism to the layout. Like pattern, rhythm should be considered relative to its effect on content, purpose, and visual appearance **(fig. 13-2)**.

single modular unit

two units, equally spaced

multiple units, equally spaced

groups of units, equally spaced

Fig. 13-1. Pattern.

Pattern is especially suited for design applications requiring a recurrent surface treatment, such as endpapers, backgrounds, fabric patterns, wall coverings, packaging, and decorative wrapping papers. Rudy VanderLans and Zuzana Licko, innovative and enormously influential proprietors of Emigre, created patterned wrapping papers for distribution through their design-product catalog **(fig. 13-3).** The sheets are excellent examples of decorative surface design, featuring patterns generated from illustration or *picture fonts* designed and/or marketed by Emigre. Picture fonts are, as the name implies, individual pictures, icons, symbols, or illustrations in a keyboard-accessible font format. Each icon is the same width and, like a conventional typographic font, is assigned a keystroke, making geometric composition very efficient. As with a regular font, the designer can adjust

Fig. 13-2. Rhythm.

point size, line spacing, and tracking to precisely control the tightness and fit of the pattern. Picture fonts are ideal for constructing running borders and for encompassing or dividing areas of a layout, placing visual emphasis on text or image **(fig. 13-4).**

The origin of digital illustration fonts is found in early *typographic ornaments* and *printer's cuts,* typically used in letterpress printing. Painstakingly drawn decorative illustrations were reproduced as engraved, type-high modular units which could then be blocked up on the press bed to create patterns and borders. Printers purchased individual units, running sections, and corners, enabling them to print patterns, borders, and frames in a variety of arrangements **(fig. 13-5).** Today these antique cuts are readily available in book and CD-ROM collections.

Fig. 13-3. Zuzana Licko, wrapping papers, illustration fonts, FellaParts (Ed Fella), Whirligig (Zuzana Licko). Emigre, 2000.

Designers are particularly adept at finding interesting image resources to stimulate creativity and provide visual distinction. Designer, musician, and letterpress printer Bruce Licher makes masterful use of antique printer's cuts, typographic ornaments, and rules to craft his extraordinarily rhythmic designs **(fig. 13-6).** Like Emigre, Licher produces projects in music and design, making pattern and rhythm particularly relevant to his work. As discussed in previous chapters, in letterpress printing the designer works with foundry type, illustration cuts, rules, hairlines, decorative devices, and polymer plates, assembling the modular elements directly on the press bed for printing. The strong use of repetitive design prevalent in Licher's work reflects the modular nature of his production process—a letterpress lock-up, like pattern, is comprised of repeated modules. His detailed and complex weaving of type, image, and decorative borders, together with his amazing presswork, instills his projects with a strong physicality and artisanlike persona.

The use of repetition imparts coherence to a layout, while rhythm provides variation. A layout can become boringly monotonous when the designer maintains a predictable adherence to gridlike repetition. However, even working within the constraints of a grid, visual adjustments in size, placement, graphic treatment, and spacing generate movement and diversity **(fig. 13-7).**

Rick Vaughn's screenprinted poster commemorating the tenth anniversary of the Duke City Marathon exemplifies how dynamically interesting "repetition with variation" can be **(fig. 13-8).** The poster's powerfully pictographic imagery places the event within the cultural and geographical context of the Southwest, while the number 10, for "tenth anniversary," provides a basis for the structural framework. The extremely horizontal format is dictated by the

Fig. 13-4. Running border using the illustration font Whirligig Two Regular, font design by Zuzana Licko. Emigre, 1994.

Fig. 13-5. Victorian printer's cuts, type catalog, George Bruce's Son and Company, NY, 1882. *Victorian Frames, Borders and Cuts,* Dover Publications, 1976.

strict horizontal blocking-up of ten runners, one for each year of the race, symmetrically arrayed on either side of a bold Roman numeral X. Variation is shrewdly applied in a number of ways: the geometric, same-size runners run toward the X from left to right on one side of center, and right to left on the other; the background panels behind each runner, and thus the runners themselves, alternate between black and red; the numeral X is printed in yellow, breaking the horizontal pattern while establishing the focal point of the layout; and the typographic text is widely letterspaced, creating a running border, reiterating the horizontal format. Every aspect of the poster—text, graphic illustration, layout, color, and print production—is intimately and resolutely integrated, confidently fixed, yet artistically expressive.

Fig. 13-6. Bruce Licher, miscellaneous projects. Independent Project Records and Press, 2001.

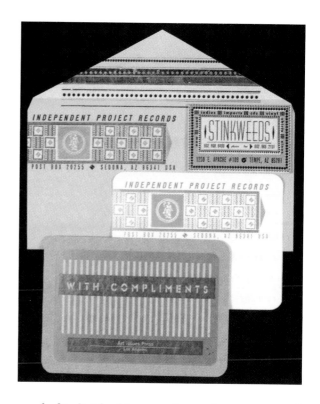

Typographic text is composed of individual letter units, and so pattern and rhythm are ubiquitous in typographic design. William G. Green, designer of the *16 Songs/16 Issues* catalog, exploited the repetitive title and the two lists of sixteen issues and sixteen artists to create an austerely rhythmic cover layout **(fig. 13-9).** In Green's design, rhythm and pattern operate in three dimensions, horizontally, vertically, and, through overlapping, from front to back. The exhibition was comprised of sixteen word concepts, created by Hachivi Edgar Heap of Birds, as interpreted by Heap of Birds and contemporary Aboriginal artists of Australia. The cover design seems to resonate with the rhythm of song, each letter in the flip-flopped title (song/issues, issue/songs) reminiscent of a single note or beat. The flush-right vertical columns, varying in point size and color, appear to advance and recede while engaging in subtle interplay with the other typographic elements. Despite the implication of an underlying grid, the exact placement of elements in the *kinetically* active design is largely *intuitive*.

Steve Wedeen's bright and amusing poster announcing his daughter's graduation from high school is the epitome of typographic rhythm **(fig. 13-10).** The essence of the poster is found in the graphic treatment of the cleverly written copy. On each side of the eccentrically formatted poster, the condensed text is run together in long, horizontal lines, with no punctuation, no spacing between words, and minimal space between lines. On one side, the

Fig. 13-7. Page layout: rhythm, repetition, and variation.

Fig. 13-8. Rick Vaughn, Vaughn Wedeen Creative, poster, *Lovelace Duke City Marathon, Ten Year Anniversary*, 1993.

poster presents a typographic outburst of breathlessly hurried parental expression. The delightfully repetitious, virtually unrelieved string of letters and words challenges easy comprehension. To assist readability and create rhythm, Wedeen uses value and color to highlight particular key words in the letter pattern. On the other side of the poster, Wedeen's daughter emphatically declares, in all caps, the worldly mantra of her generation, "BEENTHEREDONETHAT."

In Jeff Neumann's magazine spread for an article about composer/musician Randy Newman ("Short People"), pattern and rhythm are inseparable from content, a grid pattern of dots serving as a kind of graphic vessel for the artist's

Fig. 13-9. William G. Green, cover design, *16 Songs/16 Issues.* University of North Texas Art Gallery, 1995.

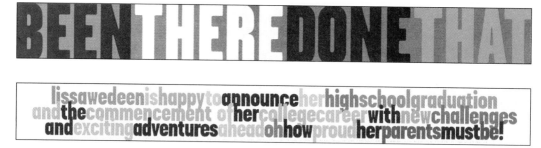

Fig. 13-10. Steve Wedeen, Vaughn Wedeen Creative, poster, *BEENTHEREDONETHAT.*

portrait **(fig. 13-11).** According to the designer, the article reveals another side of the musician, one that readers were unfamiliar with. Based on that premise, Neumann divided the artist's portrait into a geometric grid of dots, making it difficult to read the image. Comprehending the image is analogous to reading the article; only upon close scrutiny can Newman be fully perceived. Additionally, as the reader steps back from the page the image becomes more cogent, a metaphor for how we sometimes need to "step back" to see the larger picture. Over the grid pattern of dots, Neumann superimposed the title, "Beyond Short," elegantly breaking the geometry with a measured dose of typographic rhythm.

The poster, *Ultramarine,* by Kilmer and Kilmer, Brand Consultants, is comprised of several discrete "sectors" of rhythm and pattern, sensitively assembled into an interactive whole **(fig. 13-12).** Ultramarine is a technology

Fig. 13-11. Jeff Neumann, inside page design, *Beyond Short.* The Seattle Times, 2000.

Fig. 13-12. Kilmer and Kilmer, Brand Consultants, poster, *Ultramarine.* Ultramarine Software, 1990.

company producing software used to engineer offshore oil rigs. Using the ocean as a conceptual prompt, the poster's decorative imagery appropriately symbolizes various aspects of the sea—waves, seaweed, air bubbles, and a chambered nautilus, each aspect an example of *rhythm in nature*. A subtle tension exists between the horizontal, softly rolling waves and the vertical, quietly rippling seaweed. A pattern of finely tinted air bubbles, varying in size from small to large, gently rises and falls. A wire frame rendering of the chambered nautilus unfolds with rhythmic, mathematical exactness, luminous against a richly colored oceanic background. The poster portrays, in refined simplicity, an ideal world in which Ultramarine's software performs with engineering precision.

Key Words—Vocabulary for Study, Discussion, and Critique

1. Alternating
2. Cadence
3. Intuitive
4. Kinetic
5. Meter
6. Module
7. Pattern
8. Picture font
9. Printer's cut
10. Recurrence
11. Repetition
12. Rhythm
13. Rhythm in nature
14. Surface design
15. Syncopation
16. Typographic ornament

14

Emphasis, Exaggeration, and Contrast

Graphic designers use words and images, the tools of visual communication, to deliver their client's message and move the reader to some kind of action. *Emphasis, exaggeration,* and *contrast* are among the tools used by the designer to direct and focus the reader's attention. They are different methods used to achieve similar results.

Emphasis is used to create a *hierarchy* in which elements are ordered by their level of significance. To be emphatic is to be forceful or definite in expression.

Exaggeration is an aggressive and visually obvious way to highlight certain features of a layout and reinforce the narrative content. To exaggerate is to overstate or even distort something for effect.

Contrast directs the reader's attention to key elements of the layout by accentuating *difference.* On the most fundamental perceptual level, we are able to identify objects in our environment because they are different in appearance from other objects. In graphic design, contrast is achieved by creating a heightened *opposition* between elements.

Emphasis

The Limbourg brothers' *Book of Hours,* commissioned in 1416 by the Duc de Berry for his library in France, demonstrates how an emphatic arrangement of text and image can be used to focus the reader's attention **(fig. 14-1).** On this page from the magnificent book of hourly prayers and religious texts, an irregularly shaped "window" frames a narrative painting of the Annunciation. The intricate detail and visual density of the framed painting is in dramatic contrast to the generous *margins* surrounding the illustration, ensuring that the reader's meditation is on the central panel. In the margins surrounding the window, small, elaborately painted angels are delicately positioned to create a circular movement, directing the reader's eye from the marginalia back to the center of the page. Anchoring the composition are two short *columns* of text situated beneath the central panel, each one highlighted by an intensely detailed illuminated letter.

Fig. 14-1. Limbourg Brothers, *The Annunciation.* Illuminated miniature from the *Très Riches du Duc de Berry: The Hours of the Virgin.* 1416. Ms. 65, f.26 recto. Photo: R. G. Ojeda. Réunion des Musées Nationaux / Art Resource, NY.

In his poster publicizing the Northern Star train service from Paris to Brussels and Amsterdam, the modernist Ukrainian designer A. M. Cassandre (Adolphe Jean-Marie Mouron) achieved visual emphasis through an intricate management of design fundamentals **(fig. 14-2).** Using highly stylized train tracks and extreme *perspective,* Cassandre directs the eye from the hand-painted text, "Étoile du Nord" at the bottom of the *layout,* upward and through a deep, uncluttered vista to the symbolic north star at the top. The reader's eye, like the train and its tracks, "travels" in a northerly direction on the page, ultimately arriving at the very top, the northern cardinal point of the layout. As is typical of Cassandre's brilliant body of work, the poster's modern yet romantic narrative is enriched by his intimate knowledge of abstract painting, as well as his virtuoso ability to organize space.

A photographic essay documenting a historically significant neighborhood in Paris, the Goutte d'Or, is the subject of a cover design for the literary journal, *Puerto del Sol* **(fig. 14-3).** Photographs and interviews address the changing demographics and modernization of the immigrant neighborhood. The author used an underlying *grid* to establish an organizational hierarchy, to place emphasis on the photographs, and to unify the design. A brightly colored, right-angled frame, made of map sections of the Parisian neighborhood, creates a rectangle of focus in the lower right section of the cover, within which two photographs are placed. The photographs themselves are *cropped*

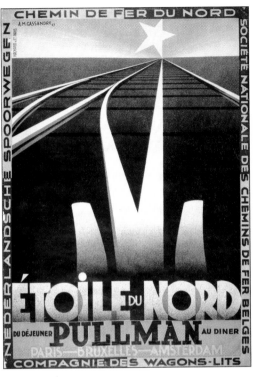

Fig. 14-2. A. M. Cassandre, poster, *Étoile du Nord, The Northern Star*, France, 1927. Victoria & Albert Museum, London / Art Resource, NY.

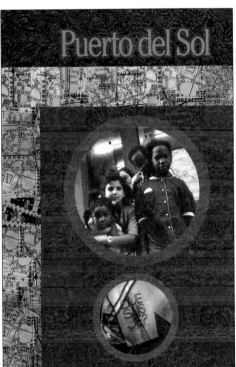

Fig. 14-3. Louis Ocepek, cover design, Mary Ellen Wolf, photography, *In the Goutte d'Or. Puerto del Sol*, English Department, New Mexico State University, spring 2001.

inside round "windows" abruptly cut into a flat, textured background of Arabic script and North African fabric patterns. (Each of the visual elements used in the cover design, including background textures, is relevant to the subject.) The upper window, larger in diameter than the lower one, attracts the eye first; a group of children stare out at the reader from the deep interior space. The text in the smaller photograph, which, in size and placement, is the last element on the scale of visual importance, asks the intriguing question "What do I know?", encouraging the reader to open the book and learn more.

Exaggeration

An advertisement from a *Ladies' Home Journal* of 1894 **(fig. 14-4)** shows how exaggeration was used to symbolize the cleaning power of Pearline Washing Compound. The highly visible advertisement occupies the prestigious, and more expensive, outside back cover of the magazine, which at 16×12 inches is quite large; it's the last page the reader sees when reading the magazine from front to back. The confrontational ad stands out in refreshing contrast to the visually bland typesetting and illustration used in the interior of the magazine.

The image of the small boy riding the Pearline box is huge, animated, and outrageously theatrical. The box, of course, is grossly exaggerated in size, a *metaphorical* "horse" big enough to handle those tough jobs around the house.

Fig. 14-4. Anonymous, advertisement, Pearline Washing Compound. *Ladies' Home Journal*, 1894.

The boy is healthy, happy, and full of life; the product has likely been used to keep his military outfit and playroom spick-and-span. The illustrator has skillfully engraved the central image to bring out its dimensionality, while keeping the background softly tinted and secondary in importance. The name of the product is woven throughout the ad, appearing four times, even spelled out in wooden alphabet blocks. Everything about this ad, from visual form to content, is exaggerated for maximum effect.

For a poster celebrating the opening of the San Francisco–Oakland Bay Bridge, exaggeration has been used to communicate the enormous significance of this spectacular project **(fig. 14-5).** Built during the Great Depression, the bridge remains one of the longest spans in the world; building it required the most advanced engineering and construction techniques of the time, as well as an enormous financial commitment. In the poster, the bridge looms over the San Francisco Ferry Building, its size dwarfing the thousands of celebrants beneath it. The somewhat moody and subdued color of the massive structure tempers the half-hearted, strangely detached celebration. The exaggerated perspective, dramatic use of color, meticulous rendering, and large *sheet size* give this memorable poster an atmosphere of science fictionlike idealism.

Visual form, as previous examples have demonstrated, is often exaggerated to heighten or dramatize a message. The vastly exaggerated scale and extreme point of view used in a travel poster for the Caribbean island of Bermuda is

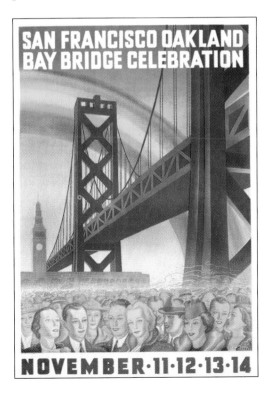

Fig. 14-5. Anonymous, poster, *San Francisco–Oakland Bay Bridge Celebration*, 1936. University Art Gallery, permanent collection, donated by Louis Ocepek, New Mexico State University.

Fig. 14-6. Anonymous, poster, *Bermuda,*
1930s. University Art Gallery, permanent
collection, donated by Louis Ocepek, New
Mexico State University.

startlingly simple and very effective **(fig. 14-6).** It displays the classic components
of the *poster* form as it existed from the late nineteenth century until the mid-
1980s—a clear and relevant concept, a simple and attractive graphic image,
limited text, a high level of readability, and a large sheet size. This poster has only
one word of copy, "Bermuda." The *headline* sweeps across the upper part of the
poster, hand lettered in *script* style, pure white against the brilliant blue sky, al-
most like skywriting. The image speaks for itself. That's all you need to know
about the subject. Blue sky fills three-quarters of the layout space, with a very
low *horizon line* near the bottom of the poster.

The *viewpoint* of the reader is from below the horizon, looking up at the
scene. Dramatically placed against the huge expanse of sky is a happy, healthy
child collecting seashells on the beach under the pleased eye of his mother.
By placing the horizon line very low in the composition, almost off the bot-
tom edge of the sheet, the designer greatly exaggerated the size of the child,
giving the poster high visual impact. The entire image is rendered almost ex-
clusively in simplified highlights and shadows; the warm skin tones in dra-
matic contrast against the blue sky. (Stylizing form using highlights and
shadows became so pervasive during this period it became known as *poster
style.*) In this poster, everything is ideal: the boy is happy, his mother is happy,
the weather is great, and the beach is clean and uncluttered. The designer
achieved maximum results with an economy of means.

Contrast

Our visual environment is defined by contrast. We are able to differentiate things and places from one another by our perception of their individual characteristics. Because contrast is so essential to perception, it's a valuable tool for graphic designers. Contrast enhances the impact and visibility of a design. The author used the opposition of black and white, a fundamental example of contrast, in his poster, *Saxophone Colossus* **(fig. 14-7),** a tribute to the great jazz musician Sonny Rollins. The poster features a large sculptural letterform *S* (the initial letter of *saxophone* and *Sonny*), constructed of black shapes and textures, positioned on a black background. The *S* has a figurative quality; it suggests a person, a saxophone and, of course, a letter. At the bottom of the layout, forming a horizon line and a base for the central character are the only two lines of text on the poster.

There are four kinds of contrast used in this poster; the first is between the light central figure and the solid black background. This simple technique ensures that the letterform is the main focus of the poster and makes

Fig. 14-7. Louis Ocepek, poster, *Sonny Rollins, Saxophone Colossus,* 2001.

an oblique reference to Black music. The second example is the contrast between the large central letterform and the much smaller type below. This contrast in *scale* makes the letter "colossal"—a reference to the title of the poster, *Saxophone Colossus* (an essential record in the Rollins discography). A third kind of contrast is found in the large central graphic where bright whites, aggressive textures, and black lines create a complex design that helps to express the edgy creativity of jazz. Finally, color contrast is used in the small text at the bottom to draw attention to the title and add a dramatic hint of color to the visual mix. The poster explores the potential of black and white design to express the energy and spirit of improvised music.

Often the *copywriting* provided to the designer when commencing work on a project can suggest a visual concept. The quotation used as the basis of a *public service* advertisement for the Container Corporation of America was instrumental in determining the design **(fig. 14-8)**. In this case, the idea of using visual contrast may have been triggered by the repeated use of the word *little* in the Samuel Johnson quotation. Once the designer focused on the idea of "little," the contrasting idea of "big" or "large" became important. (Something appears little only when contrasted with something large, or at least larger.)

In the ad, three elements are used to express the quote, scaled from large to small. The largest element is the typographic quote itself. It establishes

Fig. 14-8. Arthur Williams, institutional advertisement, *Samuel Johnson on the Art of Happiness.* Great Ideas of Western Man series, Container Corporation of America, 1952–1953 series.

the content of the ad and functions as a broad, flat layer floating over the picture plane. Nestled within the geometric text is a small, delightfully rendered full-color bird, one of the little creatures of the quote. The designer expands further on the concept by including an even smaller creature, a tiny black spider. By including this additional level of "littleness," the designer more completely addresses the idea that for so little a creature as a human, there is nothing too little for study. The reader is drawn into the advertisement in stages: first by the text, then by the bird, and finally by the spider. The advertisement was part of a long-running campaign by the Container Corporation of America to bring the great philosophical ideas of "Western Man" to the public. Each concept was interpreted by a notable graphic designer or fine artist and the intelligence, quality, and integrity of the series is unmatched in the history of corporate advertising.

The contrast between *space,* or nonimage areas, and graphic form energizes the dramatic cover, *Typography Now,* by Why Not Associates **(fig. 14-9).** A book about digital typography and its revolutionary effect on contemporary graphic design, *Typography Now* documents the *conceptual* and technical freedom made possible by the personal computer, addressing such ambitious subjects as *deconstruction* theory, *legibility, ambiguity,* and the *vernacular.* The visual form of the cover itself employs *layering,* cropping,

Fig. 14-9. Why Not Associates, book cover, *Typography Now, the Next Wave,* 1991. Photography, Rocco Redondo, Simon Scott.

and abstracted photography, boldly signaling the book's relevancy to a contemporary audience.

The fractured form of the cover design punctures the *picture plane,* making a traditional reading of the image a complex and deliberately ambiguous affair. The contrast between the richness of the color photography, the *complementary colors* used in the title, and the stark white ground seems to make reference to the deconstruction of language and image. Size contrasts within the text blocks amplify the meaning of particular words, acknowledging the complex potentialities of language. In the words of the editor, Rick Poyner, this kind of visual editing makes demands on both the reader and the designer. Adherents of this esthetic philosophy believe communication solutions should grow out of an intellectual analysis of the design assignment, taking into full consideration the visual and verbal potentialities of word and image.

The work of Rudy VanderLans, designer and editor of the influential tabloid, *Emigre,* calls into question graphic design conventions long held sacred. The cover of issue 23 shows how contrast can be used to create a powerful visual icon **(fig. 14-10).** VanderLans's design includes several ideas that were quite unorthodox in 1992. First, in an unexpected reversal of convention, the name of the magazine is very small—almost unnoticeable—and the enigmatic word *Culprits* is very large. The word is broken into two parts and

Fig. 14-10. Rudy VanderLans, cover,
Culprits, typeface, Matrix Script, Zuzana Licko.
Emigre 23, 1992.

set in a newly introduced Emigre typeface, Matrix Inline Script. Second, the designer uses an atypical (some may say awkward) color combination of dark green and orange. Third, the magazine becomes a "package" by the inclusion of a cover label reading "Better Graphic Design Inside." Last, there's a small window noticeable for its "missing" picture.

Each of VanderLans's decisions, which could be considered wrong in conventional terms, can be rationalized in the context of his personal design philosophy. The large word *Culprits* is the title of an editorial statement by the editor, written in response to vitriolic criticism of previous work created and/or represented by *Emigre*. The editor/designer of *Emigre*, and the designers featured in the magazine, are the "culprits" supposedly creating "typographic garbage." Featuring a *loaded* word so prominently on the cover creates interest while poking fun at the derisive meaning of the word. Breaking the word into two parts (but not by syllables) creates two very awkward looking words, *Culp* and *rits*. The reader has to stop and think about it. The small label takes another poke at the critics; "Better Graphic Design Inside" implies that the cover design is not so hot, but, not to worry, there's better design inside! Humor neutralizes the power of criticism.

Because the "Emigre style" of *postmodern* design questions commonly accepted standards of "beauty," experimenting with deliberately wrong colors, such as the dark green and orange used here, is legitimate. The colors are in complementary contrast as well as value contrast, giving the cover forceful visual punch and conceptual irreverence. The broad expanse of intense orange, in abrupt contrast to the dark type with its white highlights, stops traffic, capturing the eye. Some visual characteristics of the cover are carried over to the interior spreads of the magazine. The small, empty window on the cover is repeated on the *frontispiece* in the exact same location, but it's filled with a vase of flowers. As is typical of this esthetic, throughout the magazine the designer avoids the potential boredom of repetitive conformity by making unexpected decisions that reveal the design process itself. Rudy VanderLans is a master at orchestrating the unexpected.

Why Not Associates' design for an exhibition poster, *Apocalypse: Beauty and Horror in Contemporary Art* **(fig. 14-11)**, shows how visual and conceptual contrast can be used to reinforce communication. As the title of the exhibition suggests, beauty and horror do exist in contemporary art (and in life, for that matter). The designers tackled the conceptual content head-on, making it the primary visual image of the poster. "Beauty" is provided by a stereotypical photograph of a field of yellow flowers against a perfect blue sky. This delightful fantasy is disrupted by the large word *APOCALYPSE*, violently juxtaposed against the landscape. Set in a bold sans serif, the word is large and solid black against the sky; the filled-in counter forms of the letters mutate the typeface, giving the title an ominous, day of reckoning mood. The black type, positioned on the foreground layer, overpowers the pretty flowers

Fig. 14-11. Why Not Associates, poster, *Apocalypse: Beauty and Horror in Contemporary Art,* flower image photography: Photodisc. Royal Academy of Arts, 2000.

in the background, symbolically representing horror. The seemingly simple overlaying of word over image results in a visual/conceptual interplay that clearly communicates trouble in paradise.

The cover design by Jeff Neumann for the entertainment tabloid, *Ticket* **(fig. 14-12),** demonstrates how a very small image can be surprisingly effective when perfectly placed. For this cover about WCW Wrestling, Neumann wanted to avoid using a *stereotypical* image of wrestlers. He chose to use two images that are rather ordinary when viewed individually (a softly focused photograph of a wrestler's face, and a knotted rope) but that would be dramatic when used together. To achieve his goal, Neumann first made the face of the wrestler fierce and intimidating by coloring the photograph, and making it so large that it extends beyond the edge of the cover. He then strategically placed the tightly knotted rope (symbolizing the act of wrestling) directly in the wrestler's eye. The uncomfortable placement of the tiny rope (it's unpleasant to have something in your eye) immediately attracts attention and communicates the exaggerated violence of "wrestling" in an unusually dramatic way. The ring announcer's "Get ready to rumble!" is reversed out of a bright red strip, in stark contrast to the off-color background photograph. Neumann skillfully used emphasis, exaggeration, and contrast to create a smartly entertaining cover.

Fig. 14-12. Jeff Neumann, *cover, WCW Wrestling. Ticket, The Seattle Times,* 1999.

Key Words—Vocabulary for Study, Discussion, and Critique

1. Ambiguity
2. Column
3. Complementary colors
4. Conceptual (freedom)
5. Contrast
6. Copywriter
7. Cropping
8. Deconstruction
9. Emphasis
10. Exaggeration
11. Frontispiece
12. Grid
13. Headline
14. Hierarchy
15. Horizon line
16. Layering
17. Layout
18. Legibility
19. Loaded
20. Margin
21. Metaphor
22. Opposition
23. Perspective
24. Picture plane
25. Poster
26. Poster style
27. Postmodernism
28. Public service
29. Scale
30. Script
31. Sheet size
32. Space
33. Stereotype
34. Tint
35. Vernacular
36. Viewpoint

Decoration

The embellishment or ornamentation of graphic form is known as *decoration*. From one point of view, the form of graphic design—from typeface selection to graphic imagery—is determined strictly by *function*, with all design elements "stripped down" to their most efficient delineation. For a designer working from this esthetic position, decoration is considered contradictory to function. However, a successful design is one that is not only media appropriate and relevant to its audience, but also esthetically engaging. While the logic of the *"form follows function"* approach often results in a kind of natural beauty, there are occasions when both the appearance and the practicality of a design can be improved with decoration. Graphic design always consists of visual form and content. So long as content is respected, the designer has ample latitude to invest a project with decorative form, enhancing beauty and style. Used in conjunction with each of the other elements of graphic design, decoration contributes to the overall success of an assignment.

An important characteristic of decoration is its ability to elevate the quality of something familiar, or perhaps even plain, to a superior level of visual quality. Typographic form, by virtue of its universal application and recurring form, is a likely candidate for decorative manipulation. The fundamental letter shapes of the alphabet, refined into precisely sculpted sound symbols, provide an architectural framework upon which the designer can freely elaborate. Through familiarity, the reader links the elemental shape of a letter with its content, instantly identifying it as an *H*, an *O*, or a *W*. This fixed recognition allows the designer to create the most fanciful elaborations while still preserving *legibility* **(fig. 15-1).** The beautifully articulated contours and perfect proportions of Gill Sans (designed by Eric Gill in 1928) are in stark contrast to the elaborately decorative, exquisitely engraved ornamental initials. Despite the complex detailing of the ornamental letters, the eye is still able to pick out the *archetypal* letterforms (although the *W* approaches the limits of legibility). Typical elaborations applied to letters include *outlining, inlining, reversals, tonal fills,* and floral-like decorations used as a background,

Fig. 15-1. Miscellaneous ornamental letters, 19th century. *Ready-To-Use Ornamental Initials: 840 Copyright-Free Designs Printed One Side,* Dover Publications, 1994. Sans serif typeface, Gill Sans Regular, Eric Gill, 1928.

or as a convolution of the basic letter shape. Used in the right context, a decorative letterform lends interest to a project; in this example, the decorative letters are vigorously alive, showing a delightful appreciation of natural form.

Printer's ornaments are useful devices, capable of providing a charmingly decorative *accent* to an otherwise austere page **(fig. 15-2).** In the letterpress era, these etched or engraved ornamental devices were used as single elements, or as modules, arranged to create linear borders or overall blocks of pattern **(fig. 15-3).** Influenced by popular art movements such as *Art Nouveau,* the *Arts and Crafts movement,* and *Art Deco (Arts Décoratif),* printer's ornaments were also created using the lithographic process—drawn on or transferred directly to traditional lithographic stones, or processed using photographic methods. Unlike conventional hand processes of the time, photographic methods could reproduce anything the designer could draw, resulting in an enormous upsurge of intricate designs. Today, available for purchase in *copyright-free* book and compact disk collections, these devices are often used as a component of typographic design, separating blocks of text, accenting a title, framing a text or graphic image, or simply providing decorative relief from visual boredom.

To satisfy their voracious appetite for new decorative design resources, designers research cultural artifacts, decorative and fine art objects, historical,

Fig. 15-2. Miscellaneous printer's ornaments, 19th century. *Pictorial Archive of Printer's Ornaments from the Renaissance to the Twentieth Century,* Dover Publications, 1984.

geographic, and scientific engravings, printer's specimen books, and the so-called "minor arts," such as advertising design, *graphic ephemera,* surface design, ornamental metalwork, and *vernacular design.* An example of one such resource is the magnificent scientific monograph *Kunstformen der Natur (Art Forms in Nature),* by German biologist and philosopher Ernst Haeckel **(fig. 15-4).** The one hundred lithographic plates, executed by Adolf Giltsch from Haeckel's original drawings from observation, demonstrate with almost surreal detail the fantastic design esthetic inherent in exotic life forms. Appealing design characteristics such as symmetry, repetition, rhythm, pattern, texture, and color are brilliantly exploited in this extraordinary book.

The decorative exploitation of design motifs from nature found perhaps its most fertile expression in the international esthetic movement of

Fig. 15-3. Miscellaneous Victorian borders, type catalog, George Bruce's Son and Company, 1882. *Victorian Frames, Borders and Cuts,* Dover Publications, 1976.

1890–1910, Art Nouveau. Recognized primarily for its fluidity of line, floral ornamentation, and organic theatricality, in graphic design one of its most visible and accomplished proponents was Alphonse Mucha (1860–1939) of Czechoslovakia (present-day Czech Republic). Although he produced work in virtually all areas of the minor arts (the full spectrum of print formats, such as books, posters, and magazine design, as well as jewelry and textile design), Mucha is most famous for his poster production. The essential characteristics of Mucha's fabulously popular graphic style are seen in his 1898 *chromolithographic* poster for a Parisian printer **(fig. 15-5).**

The focus of the symmetrically arranged poster is on a bare-shouldered, elegantly posed woman positioned in front of an elaborately woven, wreath-like floral arrangement. The optical center of the composition is located precisely at the heart of her embroidered bodice, the design of which reflects that of the floral arrangement behind. Distracted from her civilized perusal of the picture album resting on her sumptuously folded gown, she directs her charming gaze outward, making eye contact with the viewer. The symmetrical composition is reinforced by mirrored organic abstractions, framing the centrally located, hand-lettered title panel at the top. Mucha breaks the predictability of "absolute" symmetry with subtle alterations of both the pose and the floral decorations. Mucha's high-fashion design ultimately expresses economic well-being, privileged comfort, and cultural sophistication.

Milton Glaser, cofounder with Seymour Chwast, Edward Sorel, and Reynold Ruffins, of Push Pin Studio in 1954, and, since 1974, president of

Fig. 15-4. Ernst Heinrich Haeckel, zoological illustration, *Coronata, an order of Scyphomedusae, a jellyfish,* artwork by Adolf Giltsch, polychrome lithograph, 1904. *Kunstformen der Natur (Art Forms in Nature),* Dover Publications, 1974.

Milton Glaser Inc., has been characterized as an eclectic designer. One of the most important and influential designers of the twentieth century, Glaser's work exhibits a long-standing appreciation of vernacular and decorative design, direct involvement in the social and political issues of his time, and a profound awareness of the history of art. With typical élan, Glaser's poster for the Ambler Music Festival at Temple University features a magnificently crafted *G*, or treble clef, prominently positioned over a subtle background pattern of sheet music **(fig. 15-6).** Glaser elegantly transforms the oversized *G*

Fig. 15-5. Alphonse Mucha, *F. Champenois Imprimeur, Editeur 66 Bould. St. Michel, Paris.* Color Lithograph, French, 1898. Victoria & Albert Museum, London / Art Resource, NY.

clef from a musical notation into a flowering vine, terminating it with a decorative burst of form and color. The voluptuous spirit of the entire design, positive in its vigorous upward movement and symbolic meaning, is reminiscent of Art Nouveau. The extreme enlargement of the original artwork exaggerates the expressiveness of Glaser's hand-drawn outlines, endowing the boldly graphic poster with a distinctly healthy and generous personality.

Occasionally, the decorative traditions of a particular culture can inspire a relevant graphic design solution. For the winter 1993 cover of the literary journal *Puerto del Sol,* the author created a decidedly decorative graphic illustration, influenced by traditional Hispanic tinwork of the Southwest and fine hand-embroidery such as that found on handkerchiefs, scarves, and indigenous costumes **(fig. 15-7).** Produced in New Mexico, each *Puerto del Sol* cover design, as befits its title, features at least one sun (and often more than one), usually in a stylized configuration, typically integrated into a larger context. This cover design is obsessively symmetrical, comprised of a round, centrally positioned, ornately "embroidered" sun motif, contained by a rectangular "tinwork" frame. The sun is constructed from three distinct layers of imagery: a small, brightly colored and tightly geometric "folk-art" sun located in the very heart of the design; an intricately painted, highly stylized floral design radiating out from the centralized sun *motif;* and sharply geometric sun rays radiating around the outer periphery. From each of the four

Fig. 15-6. Milton Glaser, poster, *Ambler Music Festival.* Temple University, 1967.

Fig. 15-7. Louis Ocepek, cover illustration. *Puerto del Sol,* English Department, New Mexico State University, winter 1993.

corners of the tin frame, a dimensional quarter-sun sends its light toward the center of the design. The sun is an apt metaphor for *Puerto del Sol*: it strives to illuminate or cast light on significant fiction, poetry and literary essays; it is published in New Mexico, where nearly every day is a sunny one; and the sun is the ultimate life-giving force, a powerful symbol of creativity. Decorative design is likewise an appropriate option—the Southwest is intimately identified with its folk art traditions, and the folk genre expresses the individuality and beauty of finely crafted handwork.

Milton Glaser's poster of musician Bob Dylan is, without question, one of the most recognizable graphic icons of the twentieth century **(fig. 15-8).** Among designers and music people, a simple allusion to "the Dylan poster" conjures up the familiar black profile with its psychedelic crown of undulating hair. Glaser was originally inspired by a memory of *Dada/Surrealist* Marcel Duchamp's *Self Portrait in Profile* of 1958, a compact and wonderfully simple work, in which the artist *collaged* a white, torn paper silhouette onto a black background. Remarkably (as can be seen in a live concert shot from D. A. Pennebaker's 1967 documentary, *Don't Look Back*), the equally enigmatic Dylan and Duchamp seem to have shared a nearly identical profile. Brilliantly transcending his original influence, Glaser expanded his design by delineating Dylan's signature hairstyle in sinuous swirls of color, the brightly decorative patterns in stark contrast to the moody, introspective

Fig. 15-8. Milton Glaser, Pentagram, poster, *Potlatch American Design Century, Dylan Album Poster,* 1999; original poster design, Milton Glaser, 1967.

silhouette. Glaser's Dylan poster is a definitive symbol of the 1960s, in which he used decorative design to ingeniously embody, in a singular graphic form, the mind-bending, consciousness-expanding happenings of the era. In acknowledgment of its significance, the Dylan poster was included in the 1999 commemorative series, Potlatch American Design Century.

In the work of Milton Glaser, decoration is rarely employed as an end in itself; instead, it is almost always allied with content. For a Brooklyn Museum poster **(fig. 15-9),** Glaser's imagery is derived from the double meaning of the headline copy, "Visit a Masterpiece." In the most literal reading of the headline, one makes the usual assumption that a patron goes to a museum to visit, or view, a masterpiece. However, there is a second reading, which is that, in the case of the Brooklyn Museum, the building itself is a masterpiece, well worth a visit.

The prominent architectural firm of McKim, Mead and White designed the Brooklyn Museum, which was completed in 1897. The imposing edifice, surrounded by parks and the Brooklyn Botanic Garden, is indeed a *beaux-arts* masterpiece, its eclectic academic style combining Greek, Roman, and Renaissance motifs. The poster features disparate sections of the architectural drawings for the building, reconfigured by the designer into a remarkably animated *montage.* Floating over a buff-colored background, each architectural detail sports a delightfully decorative classical motif, combined

Fig. 15-9. Milton Glaser, poster, *Visit a Masterpiece.* Brooklyn Museum, 1986.

with delicately tinted *marbleized papers*. Like most successful design, Glaser's imposing poster can be enjoyed on multiple levels: its decorative beauty is aligned with its *utilitarian* purpose; its dynamic composition is in interesting contrast to its historical subject matter; and its experimental artwork functions beautifully in its *applied design* context.

Key Words—Vocabulary for Study, Discussion and Critique

1. Accent
2. Applied design
3. Apprentice
4. Archetypal
5. Art Nouveau
6. Arts and Crafts movement
7. Art Deco (*Arts Décoratif*)
8. Chromolithography
9. Collage
10. Copyright free
11. Dada
12. Decoration
13. Eclectic
14. Form follows function
15. Function
16. Graphic ephemera
17. Inline
18. Legibility
19. Marbleized paper
20. Montage
21. Motif
22. Outline
23. Printer's ornament
24. Reversal
25. Surrealist
26. Tonal fill
27. Utilitarian
28. Vernacular design

16 Graphic Production

The term *graphic production* is used to describe the entire range of techniques and processes employed in the production, finish, and delivery of a design project. While some designers consider graphic production to be a constraint, an impediment to their creativity, others view it as an essential, and gratifying, aspect of *craft*, an opportunity to elevate the quality of their work to a higher degree of perfection. On the process level, designers derive great pleasure from the skillful use of tools, particularly when it positively affects both problem solving and image making. The ultimate rewards in graphic design (other than financial) are in the final delivery of a first-rate product, and in the positive feedback resulting from a job of work well done.

There are various ways to position graphic production within the overall design process. The most typical perspective is to place it at the very end of the process, as the finishing stage of a project. When viewed in this way, the designer *hands off* the completed components of a project, including artwork and *digital files*, to a *service bureau* or other specialized craftsperson (such as a printer, binder, or *web master*) for finish and dissemination.

Another way to position production in the design process is to see it as a critical issue to be considered at the very *inception of* a project, one that will influence every decision, from creative to financial. In this way of thinking, before any visualization takes place, the designer first considers such things as the makeup of the target audience, the budget, the timeline, and the ultimate form of delivery (such as print, electronic, or dimensional design).

Still another perspective on production is that the very conceptualization of a project can be influenced or determined by a particular *medium* of graphic production. In this scenario, the designer has an affinity for, or a desire to work with, a certain process, such as *digital imaging* or letterpress, and the process directs the conceptualization of the project. This way of working often leads to the creation of unique imagery, unusual graphic treatments, or experimental formats impossible to achieve by any other means. Regardless of the designer's point of view regarding the value or constraints

of the production process, it remains unavoidable. By definition, a graphic design project isn't complete until it's been fabricated and delivered to its audience, by whatever means are deemed appropriate.

As discussed throughout this book, graphic design projects, whatever their final form is destined to be, are made up of many constituent parts produced in a variety of ways. In the contemporary design studio, files of finished artwork and layouts are prepared almost exclusively on the computer and then handed off to production specialists for finishing. However, although the computer is without question the tool of necessity and choice (rightly so in view of its power and efficiency), designers also use a broad range of other techniques, often integrating conventional tools and processes with digital techniques. Depending on the designer's stylistic inclinations and design methodology, the creative stages of a project may involve considerable handwork, from drawing thumbnails or studies, to creating finished graphic illustrations, diagrams, or photo-manipulations. Ultimately, in the production phase of most projects, all the various components, regardless of how they were made, are gathered, converted, and assembled into their final digital form **(fig. 16-1)**. As demonstrated by the following projects, an essential attribute of the successful designer is versatility—the talent and flexibility to embrace whatever tools, materials, and processes are needed to fulfill the creative and technical requirements of each commission.

Throughout his distinguished career, legendary American modernist designer Bradbury Thompson integrated the tools, processes, and imagery of the graphic arts into the very fabric of his pioneering designs. Perhaps best known as the designer, from 1939 to 1962, of sixty-one issues of the innovative graphic arts publication *Westvaco Inspirations,* Thompson's work often

Fig. 16-1. Elements of graphic production.

reveals in visual form the very process by which the work itself is produced. As a participant in the Container Corporation of America's groundbreaking institutional advertising campaign Great Ideas of Western Man, Thompson's contribution exemplifies his extraordinary ability to fuse order and structure with improvisation and experiment **(fig. 16-2).** Thompson's design, based on a quotation by Justice Lindley on protection from government, is anchored by two representations of the scales of justice, one a small conventional piece of line art, and the other a set of highly stylized *color separations.*

Although the layout is essentially symmetrical in form, its optical center focused on the two sets of scales, Thompson creates dynamism by boldly overlaying the skewed color separations over the line art. The visual strength of Thompson's design effectively communicates the fundamental nature of the justice system itself—the careful weighing of evidence tipping the scales from side to side, until a just decision is reached. The startlingly graphic deconstruction/reconstruction of the printing process is orderly yet expressive, conventional yet experimental. Above all, the design serves as a relevant response to the meaning of the text, and the spirit of the campaign.

The poster, *Emigre Magazine, the Magazine That Ignores Boundaries,* by Emigre's Rudy VanderLans, is an exuberantly self-referential exploration of the graphic production process **(fig. 16-3).** Produced and printed as an artist-in-residence project at the Visual Studies Workshop in Rochester, New York,

Fig. 16-2. Bradbury Thompson, institutional advertisement, *Mr. Justice Lindley on Protection from Government.* Great Ideas of Western Man series, Container Corporation of America, 1953–1954 series.

Fig. 16-3. Rudy VanderLans, poster, *Emigre Magazine, the Magazine That Ignores Boundaries,* Emigre Graphics, 1985.

the two-sided promotional poster adopts the form of an unfolded, untrimmed *press sheet.* The deceptively casual layout, a raucous montage of broken words and disjointed images, is filled to the brim with verbal and visual puns. Even the most nonchalant viewer is inevitably seduced by VanderLans's confident exploitation of the print medium. *Process color, spot color, transparency, overprinting, positives, negatives, reversals, matte and glossy inks, line art, halftones, printer's marks*—the full spectrum of graphic art techniques coexist in vigorous disharmony.

The production requirements of some graphic design projects go far beyond those of the usual print or electronic application. The work of Why Not Associates (Andrew Altman, David Ellis, and Patrick Morrissey) is radically unconventional, ambitious in its wide-ranging engagement with various media and memorable for its adventurous approach to form. The steps of the Tam O'Shanter Inn, located in Ayr, Scotland, exemplify the studio's ability to produce a complex work that operates on the artistic as well as functional level **(fig. 16-4).** A memorial to the illustrious eighteenth-century Scottish bard, Robert Burns, the shot-blasted granite steps feature excerpts from his celebrated poem, "Tam O'Shanter."

In addition to the design talents routinely required for any assignment, a project of this kind calls for an understanding of environmental space, a sensitivity to surrounding structures and historical context, an appreciation of

Fig. 16-4. Why Not Associates, *Tam O'Shanter Steps.* Ayr, Scotland, 1997. Photography, Andrew Miller.

the esthetic quality and suitability of particular building materials, and the willingness and capacity to work in a cooperative spirit with others. To produce a project of this scope often requires at least some involvement with local government, a selection committee, an architectural standards board, and external contractors and suppliers (in this case, architectural stonemasons). As befits its reputation for optimistic daring, Why Not Associates successfully negotiated the bureaucratic complexities of *environmental design* and *public art,* producing an accessible and spirited work of admirable typographic clarity.

Rick Valicenti's luxuriously fabricated letterpress portfolio, *Killing Pretty,* is a powerfully enigmatic work rooted in intense personal exploration **(figs. 16-5, 16-6).** Derived directly from Valicenti's doodles augmented with typographic collage, the portfolio of individual sheets gains its graphic power not only from the artist's artistic sensibility, but also from the sumptuous quality of the printing. The rich, matte color, sharply delineated detail, and *blind embossing* deeply impressed into the thick, handmade paper help make Valicenti's improvisations an elegant tribute to the art of design and printing. The superb production values elevate the arcane word pictures beyond their modest beginnings, enhancing their psychological weight and intellectual meaning.

The poster Milton Glaser designed for his exhibition at the Philadelphia Museum of Art, *Design, Influence and Process,* succinctly demystifies the very

Fig. 16-5. Rick Valicenti, Thirst, letterpress portfolio, *Killing Pretty.* Gilbert Paper, 1994.

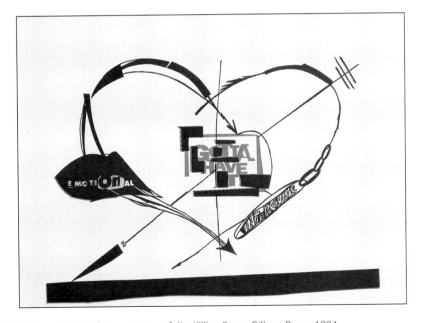

Fig. 16-6. Rick Valicenti, Thirst, letterpress portfolio, *Killing Pretty.* Gilbert Paper, 1994.

Fig. 16-7. Milton Glaser, poster, *Design, Influence and Process*. Philadelphia Museum of Art, 2000.

manner by which the poster itself was created **(fig. 16-7).** Glaser employs a "picture within a picture within a picture" (the intriguing visual phenomenon he describes as *infinite regress*) to graphically diagram the three stages of the design process listed in the poster's title. Glaser draws a direct (red) line from his preliminary sketchbook study of the poster, to the full-sized finished illustration, literally and figuratively connecting the research, creative, and production phases of the process. Glaser's generously sized poster, beautifully printed on heavyweight paper stock, honors the innate power of the singular image; in this case, a delightfully decorative architectural ornament from the museum's Greek revival façade. Once again, Glaser demonstrates his legendary ability to expand what appears to be a modest visual concept to the superior prominence of graphic icon.

Key Words—Vocabulary for Study, Discussion, and Critique

1. Blind embossing
2. Color separation
3. Craft
4. Digital files
5. Digital imaging
6. Environmental design
7. Glossy
8. Graphic production
9. Halftone
10. Handing off
11. Infinite regress
12. Line art

13. Matte
14. Media
15. Negative
16. Overprint
17. Positive
18. Press sheet
19. Printer's marks

20. Process color
21. Public art
22. Reversal
23. Service bureau
24. Spot color
25. Transparency
26. Web master

Index